Images of the Rust Belt

Images of the Rust Belt

JAMES JEFFREY HIGGINS

The Kent State University Press ⊠ KENT, OHIO, & LONDON

© 1999 by The Kent State University Press, Kent, Ohio 44242

Library of Congress Catalog Card Number 98-48657

ISBN 0-87338-626-4

Manufactured in China.

05 04 03 02 01 00 99 5 4 3 2 1

Library of Congress Cataloging-in-Publication Data

Higgins, James Jeffrey, 1958–

Images of the Rust Belt / James Jeffrey Higgins.

p. cm.

ISBN 0-87338-626-4 (cloth : alk. paper) ∞

1. Photography, Industrial—Middle West. 2. Landscape photography—Middle West.

3. Mills and Mill-work in art.

4. Steel industry and trade—Middle West—Pictorial works. I. Title.

TR706.H53 1999

779'.960978—dc21 98-48657

British Library Cataloging-in-Publication data are available.

To Tom & Ellen Cornelius, Christine Dunn, and my mother—
for their unswerving faith in me as a photographer.

Contents

Foreword

BY ROBERT GLENN KETCHUM

I first met Jeffrey Higgins when he asked me to look at his work. Much like my own photography, a portion of his subject matter is based on the straightforward depiction of nature, and I could easily appreciate his personal sense of composition and color. But there were other images within his portfolio that I found the most interesting of all. His rather quiet observations of industrial sites evoked a subtle and strangely provocative sense of place that continued to linger in my mind well after my initial viewing.

Jeffrey created most of his images in the Cleveland-Akron area of Ohio where he lives, and a place with which I am very familiar through a previous project of my own. Formerly one of the great industrial centers of the nation, this region has been in significant transition as new technologies and businesses of the latter part of the twentieth century replace the traditional manufacturing, primarily rubber and steel, and as the huge physical plants that many of these former industries required have been abandoned. Fueled by wet winters and humid summers, the lush countryside of Ohio has begun to reclaim those structures that are not being maintained, and it is in these locations that Jeffrey has found a personal visual resonance.

Usually the best work an artist produces is that which is close to his or her heart. The creative response is often without much calculated thought. More likely it is an internal emotional reaction to something so familiar that it reflects an intuitive understanding of the subject, rather than an intentionally crafted one. This is the strength of Jeffrey Higgins's photography.

Personally connected to this landscape, these images are not struggling to communicate some burning truth. There is no visual commentary about the successes or failures these transitional relics symbolize. The pictures seem almost casual. They hold no message beyond the pure photographic beauty of the artist's vision. Yet they suggest more. They are not "romantic" either, regardless of the words thrown carelessly around by critics of this medium. The photographer has simply found and addressed the significance of these subjects through his observations and familiarity. Most importantly, he recognizes the integration of the structures and the landscape, which has infused the images with splashes of the remnant industrial colors and the often warm and sultry light that emanates, seemingly, from within the countryside.

To Jeffrey, these pictures simply represent "the way it is," the way

that he has repeatedly found it on his photographic forays. His dialogue is not affected with the language of "art." His pictures are of "real" time and real places, and that is their importance. They speak to us of something we all know—the essence of change, whether it be the fleeting moment of light or the slow passing of an age.

Acknowledgments

❊ ❊ ❊

When I first began this project, I never thought I would come in contact with so many people who would contribute so much to its success. Many of these individuals have since become good friends, offering words of encouragement when I needed them most. Without them this project would never have come to fruition, and I would like to thank a few of them by name.

First and foremost, as always, I acknowledge the divine inspiration from above.

I extend my deepest thanks to my mentor, Robert Glenn Ketchum, who has also become my friend. For his belief in me and his willingness to be involved in this project, I am indebted to him more than words can adequately express. I am also grateful to Mr. David Cooper of the *Akron Beacon Journal* for his fine introduction to the text. His friendship and encouragement have been unequaled, especially during those days when I was unable to see the forest for the trees. Thank you, David, for everything.

A special thanks to U.S. Congressman Jim Traficant for his inspiring endorsement and his belief that what I was doing would play a small role in changing peoples' perceptions of our industrial Midwest.

I would also like to thank John Hubbell and everyone at The Kent State University Press for bringing this project to print.

Thanks to Sue Virgalette, who helped me with editing the proposal that led to this publication. Her ideas and expertise in proposal writing have been invaluable. I would also like to commend everyone at the Hubbard Library who helped me locate information used in the compilation of this book.

I have had the wonderful pleasure of knowing a couple of people who contributed immeasurably to my success. I am grateful to Joel and Nancy Sabella for letting me work in their place of business, where I mounted and assembled my images for exhibition. Their personal sacrifice and generosity will not go unnoticed.

Some special friends stood by me through thick and thin. First and foremost there is Kim Horvat. Thank you, Kimberly, for your wonderful support, for the coffee and long talks that lasted until morning. Thanks, too, to Jerry and Cindy Taafe for allowing me to bounce ideas off them, and for a friendship that I hope lasts a lifetime. And I thank Jay and Diane Crafton for their encouraging words and belief in what I was doing.

Grateful thanks to Robert and Virginia Dixon for their help transporting my photographs to various galleries in and around Ohio. I also extend a special note of appreciation to Sally Myers (with a small dedication to her husband, Jim) for her proofreading of my many papers and texts.

Having been involved with this project as long as I have, it has presented me with many opportunities to push the limits of both the film and the camera. All of these images were made with a Pentax 6×7 camera and four lenses—55 mm, 75 mm, 105 mm, and 200 mm. I have encountered no other camera that has worked as wonderfully and faithfully as my 6×7. Similarly, the TTL is the most accurate light meter I have ever worked with. During this project I used it exclusively and made all the images without the use of filters, except the UV filter to protect the lens glass. All of the photographs for this book were made with Fujichrome 50 and Fujichrome Velvia slide film. The exposures were not calculated, because a substantial number of them were very long. I have grown to understand the reaction of the film under a variety of circumstances and have learned how to use it to my advantage. Some of these photographs were literally years in the making.

James Jeffrey Higgins

Introduction

BY DAVID B. COOPER

❋ ❋ ❋

We are walking through the woods, James Jeffrey Higgins and I. It is a cool day in midspring, still damp in the woods from an early-morning rain. Higgins is on the prowl for a new vista or wisp of the northeast Ohio landscape to fill the frame of his camera, and I am tagging along.

Higgins is a tall, lanky man with a long stride. He is wearing a gray hooded sweatshirt beneath a dark-blue windbreaker. His clothes are clean and neat, but his jeans and boots show the wear of being in the woods often.

He has his camera bag slung over one shoulder. He carries his tripod against his other shoulder. We have not driven far—no more than two miles—from where Higgins lives, in a three-room basement apartment beneath an accountant's office in his hometown of Hubbard, Ohio.

Hubbard is a suburb of Youngstown, the Ohio steel-mill city that more than any other Ohio city came in the late 1970s and the 1980s to typify the term "Rust Belt." As the nation's economy took a nosedive, many of the great mills of Youngstown closed. Their huge furnaces that made the steel that was used to build many American products shut down. The steelworkers of Youngstown and Hubbard and their fami-

lies still feel the pain and the pinch. The size of these idle mills has to be seen to be understood; their scale rivals that of Ford's huge River Rouge plant outside Detroit.

Jeffrey Higgins, who was born on May 29, 1958, grew up in a pleasant, well-kept, blue-collar neighborhood just around the corner from where he now lives and not far from the mighty mills that once belched flame and prosperity in the Mahoning Valley. He knows Hubbard, which has a population of about nine thousand today, as well as he knows the woods and the fields nearby.

He has photographed all over this part of Ohio, in western Pennsylvania, and down along the Ohio River in towns such as Steubenville, East Liverpool, and New Philadelphia. His camera and his camera-eye take him where he thinks he will find slices of the natural and the man-made landscape that will make interesting color photographs.

Often, however, as is the case on our jaunt through the woods, his search does not take him far from home.

We have driven just a few minutes from his house when we stop by a railroad track on Fox North Road and park the car. We walk along the tracks and then take a path into the woods and walk along Yankee

Run Creek. An east-west canal was a transportation link through this section of Ohio more than a century ago, and occasionally we walk along the remnants of its towpath.

Higgins finds a sense of both local history and personal history in these woods that draws him back time and again. He is one of four children; his three sisters are all younger.

"My father spent a lot of time taking us down in the woods," he says. "It had a profound influence on me, maybe more than I realize." At one point in our walk, he points ahead and says, "My dad told me my grandfather told him there used to be a bridge here over the stream." Farther on, he says, "They used to farm cattle down here in this bottom."

Ten minutes later he stops, spotting a possibility, a tangle of limbs and tree trunks leaning over the stream. The branches seem to make a frame. He pauses, sets up his tripod, takes his Pentax 6×7 camera with a 105-millimeter lens out of his bag, mounts it on the tripod, and centers his camera-eye focus on the scene. He adjusts this way and that; he moves with the camera and tripod. "I can see those little blue flowers way over there," he says, "and I think, 'Oh, that looks really interesting.'"

Jeffrey Higgins is almost totally self-taught as a photographer. He graduated from Hubbard High School in 1976. When I ask him what he did after that, he laughs a bit and describes a beginning career as a "petroleum transfer engineer." When I look puzzled, he explains that he worked the pumps at a gas station.

Later, he was a press operator in a factory, making the hangers for big sprinkler systems. He was making $9.21 an hour after about seven years on the job when he badly injured his back lifting heavy material. Since then he has at times driven a truck for a potato chip company, tended bar, and waited on tables, among other jobs.

What he really has become is a professional photographer who takes marvelous pictures of some of the toughest landscape and abandoned factories anywhere. Several one-man shows, including ones in Cleveland and Ashtabula, Ohio, as well as private commissions, have sparked sales of his prints that help support him.

Many of the places Higgins goes with his camera would seem torn, defiled, and even scorched by mankind, by mills and refuse, by logging and mining, by toxic waste dumping, and by general abuse and misuse of the natural environment. Even so, it is in such places that Higgins finds what he sees as magic before his camera lens.

"I was brought up to believe that this was just a steel town," he has written, "and that nothing good could come from here." His photographer's vision was influenced by his exposure to the nineteenth-century landscape paintings of the Hudson River School of painters. He wanted his photos to show more than rusted old steel mills and abandoned city streets: "I wanted to show the viewer images that no one thought to photograph and to capture them in such a way that would bring honor and reverence to this part of the country. I wanted to change people's perception of the 'Rust Belt' and to challenge their understanding of what is beautiful. As my vision became more acute, so did my understanding of what is beautiful."

He has learned—initially through seeing at the Akron Art Museum in the late 1980s Robert Glenn Ketchum's photographs of Ohio's Cuyahoga Valley—that he does not need to be in such magnificent national parks as Yosemite or Yellowstone to make interesting color photographs.

Later during our day together, we stop near an abandoned plant site. "This was basically a dump when I photographed it," Higgins says. "I found it really interesting that I could make a really nice picture in a place they used to dump old refrigerators and stoves. I kept coming back here until one early morning the mist had that really light-blue glow to it."

Higgins employs great patience to get the light and tone he desires in a photograph. He spent three summers driving to Midland, Pennsylvania, to get just the perfect pink glow of dawn in what turned out to be a stunning photo of cooling towers at the nuclear power plant there along the Ohio River.

As he shows me a large print of a photo taken in the fall in the woods near his home, he says, "I was out galavanting and I remembered this old, logged-out hillside, and it was a drizzly day and I was standing on the hood of my car in the pouring rain for half an hour to get that picture."

No one has done more to encourage Higgins in his work than Ketchum, who in recent years, starting about the time he completed his photographic project in the Cuyahoga Valley between Cleveland and Akron, has become one of the most internationally acclaimed and respected of all environmental photographers.

It is to Ketchum's credit that, after Higgins first saw Ketchum's Cuyahoga Valley photographs, he called and asked if Ketchum would critique his work. Ketchum agreed and reviewed Higgins's slides while he was later having a show in Cleveland. Ketchum encouraged the young photographer from Hubbard, and Higgins has never looked back.

While the medium is the same, and while some may see Higgins as a follower of Ketchum, I think his vision is somewhat different. When the hand of man intrudes into the landscape of a Ketchum photograph, it is most often to show how man has befouled the landscape's natural beauty. Higgins, in contrast, sees both beauty and interesting images in the most abject examples of mankind's scars and manipulations on the natural environment. Higgins finds majesty and context in what many would quickly pass by as ugly and mundane.

Jeffrey Higgins is still learning. He is a considerable talent who is growing and constantly shaving off rough edges. As his work in this book shows, he has a fine eye that produces fine photographs, even in the hard-scrabble, scarred landscape of his youth. Watching him at work and walking through the woods with him, I became convinced of his commitment and dedication to the practice of his remarkable art.

The End of an Era and the
Changing Face of Our Industrial Landscape

Over the last 150 years, steel production has played a vital role in the shaping of our nation. This was especially true in Youngstown, Ohio, a place often referred to as "the Rust Belt." In their heyday, the Youngstown mills ran along twenty-five miles of the Mahoning River and employed tens of thousands of people. At one time the classified ads around the country read "If you want a job go to Youngstown, Ohio."

But all of that changed in September 1977 when the LTV Corporation announced that it was closing its Youngstown Works. Five thousand people lost their jobs that day, and this part of the country has never fully recovered from that decision. Mainly due to a lack of industrial diversification, as well as the negative publicity that surrounded the mill closing, Youngstown today struggles for its survival.

When I look back over the last twenty years, it is hard to believe how different the area has become. Now, as I drive along some of those same city streets, I am constantly reminded of that change. The once-bustling streets and thriving businesses are gone. Most of the buildings are vacant and run down and the neighborhoods desolate.

Over 100,000 steel-related jobs were lost due to that fateful decision in 1977. I cannot imagine what those people felt upon learning of the mill closings. But in walking along some of those abandoned dirt roads where the mills once stood, I have gained a better understanding of what the workers held so dear. Although most of the mills are gone, and all that's left are vestiges of the past, I wanted to show the reader just how beautiful traces of the past can be.

I was never fully aware of the strength of my feelings for the area and people that made steel production their livelihood until I began this project. The deeper I immersed myself in it, however, the more I thought about those feelings, and the more I knew I needed to continue this venture in the hope that it would bring to light a better understanding of the nature of the change the Rust Belt has undergone. I came to understand how important it was for the people to be represented in such a way that would bring praise to their accomplishments as well as to their surrounding landscape.

As the project progressed, I found myself spending a substantial amount of time studying the work of the Hudson River painters. Completely captivated by their renditions of our natural world, I wondered about that lost innocence. How did they manage to capture so well a world so full of promise and passion? I wondered how I could incorpo-

rate this newfound sense of vision into my own work. How could I ignite this passion for my little part of the world?

I realized that I needed to rethink what I was doing with my camera and approach the project from a different standpoint. It was at this time that I was introduced to the work of photographer Robert Glenn Ketchum, whose masterful sense of composition and selection became a model for me. Setting out with my new vision, I searched for places where I could best incorporate my understanding of the local landscape. Knowing I would not find any majestic vistas, I needed to approach this from a more personal point of view in order to capture the feelings I was looking for.

I was brought up to think that this was just a steel town and that nothing good could come from here. Nothing special or beautiful. This was one of the first things I wanted to change. I wanted to dispell any notions that this part of the country is not magical beyond belief. I set out to capture the feelings I had as a child—that overwhelming feeling when you see something you cannot fully articulate or even understand but that speaks to you deep inside. As the project progressed I became more aware of what I was trying to do with my camera, and of just how magnificent this surrounding landscape really is.

I wanted to show the viewers images no one had thought to photograph and to capture them in such a way that would bring honor and reverence to this part of the country. I wanted to change peoples' perceptions of the Rust Belt—with its images of rusted old steel mills and abandoned city streets—and to challenge their understanding of what is beautiful.

Some of the pictures evoke a strong sense of what once was but will never be again. In taking this approach to the project, I was concerned that it not dismiss the larger problems inherent to the political, economic, and cultural changes that have taken place here since the mills closed in 1977.

The steel industry was for a long time—in my family's case, three generations—one of the best places to be employed. It offered many of us a higher standard of living and the opportunity to make a better life for ourselves and our families. My great-grandfather, my grandfather, and my father were all under the assumption that this life would continue forever. And when I graduated from high school in 1976, I, too, was destined for the mills. It was the sensible thing to do. While some of my friends did go on to receive their college degrees, in the early and mid-1970s one was better off financially working in the factories. While signs of trouble were evident even then, I suppose I assumed— or hoped—that the government would step in and do something to keep this part of the country from going under.

But over time, increasingly unresolvable management-labor disputes, rapid advancements in technology, and a shift in the national priority weakened the once-strong industry and its vital workforce.

It is hard for us to imagine that many of these people took for granted that they would work for one employer for forty years, until retirement. Today, workers change jobs at least three times in their careers. Myself, I have not worked for a single employer for longer than five years, and during the early eighties I had as many as six or seven jobs in one year.

Being born and raised in this part of the country has taught me that things change, that nothing lasts forever. I have also come to believe that not all change is for the better. I read in the newspaper about the soaringly rich stock market, yet turn the page and learn of someone who is struggling to keep a roof over his head. I hear government officials boasting about how good the economy is, about how everyone who wants a job is working. But what sorts of jobs are these?

I knew that the photographs had to be more than mere representations of our industrial Midwest; they had to show the viewer the complexity of this part of the country. The image of the cooling towers had to be photographed in such a way as to leave the viewer wondering if

they were real, if they ever really existed. I wanted to capture a city at dawn, when the sun turns the fog a splendid pink and leaves us wondering if it is an image of storage tanks as they stand guard over the city or if it is a city with storage tanks in it.

So as I walk in the woods where I live, I realize that through this project I have come to revere this place I call home. My hope is that in seeking to harmonize the industrials with the landscapes, in making images that seem larger than life and that command your attention, in convincing readers to take another look, I will have struck a responsive chord in everyone.

Images of the Rust Belt

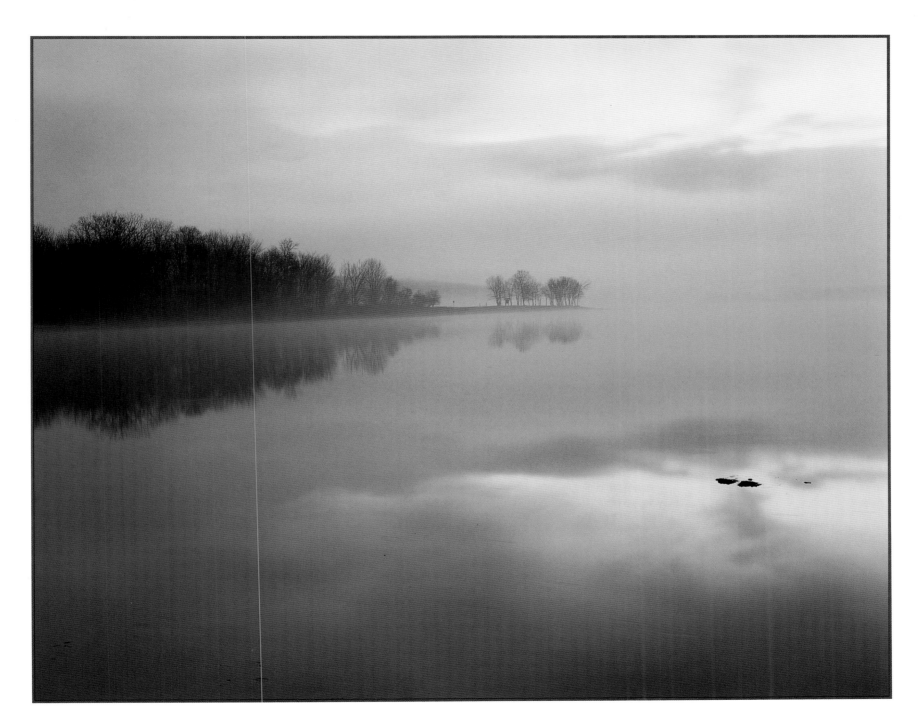

Sunrise on the Lake. Shenango Reservoir, Clark, Pennsylvania.

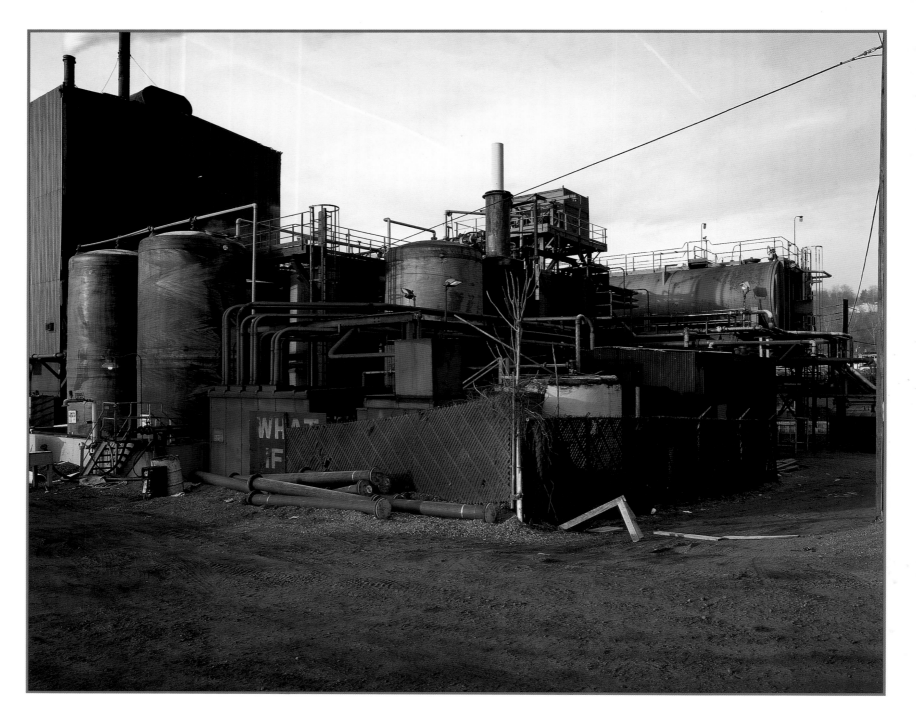

Storage Tanks at Weirton Steel. Weirton, West Virginia.

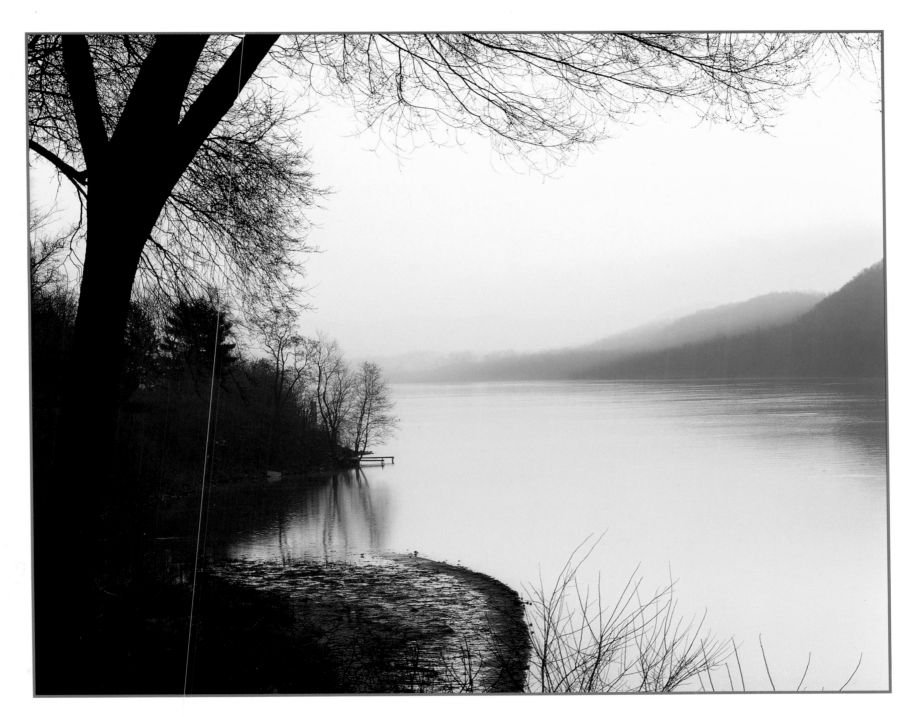

The Ohio River. East Liverpool, Ohio.

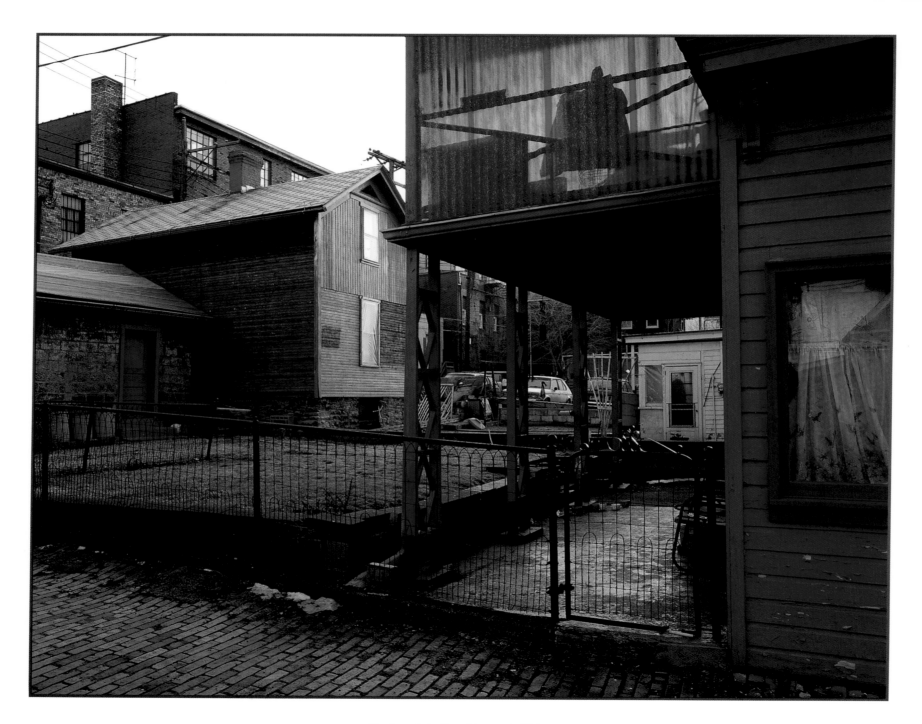

Backyards in East Liverpool, Ohio.

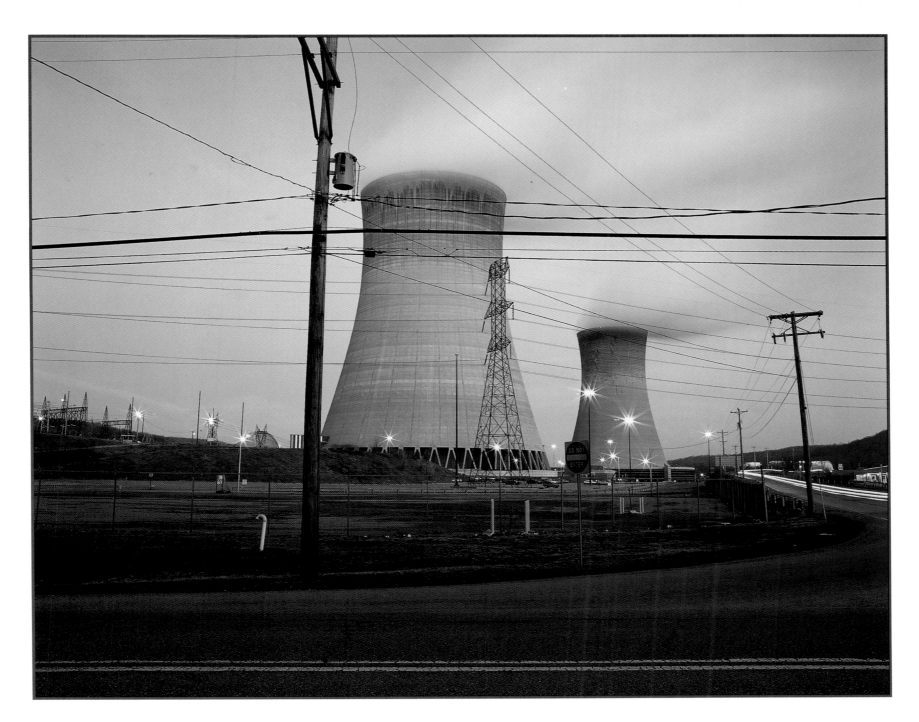

The Cooling Towers. Midland, Pennsylvania.

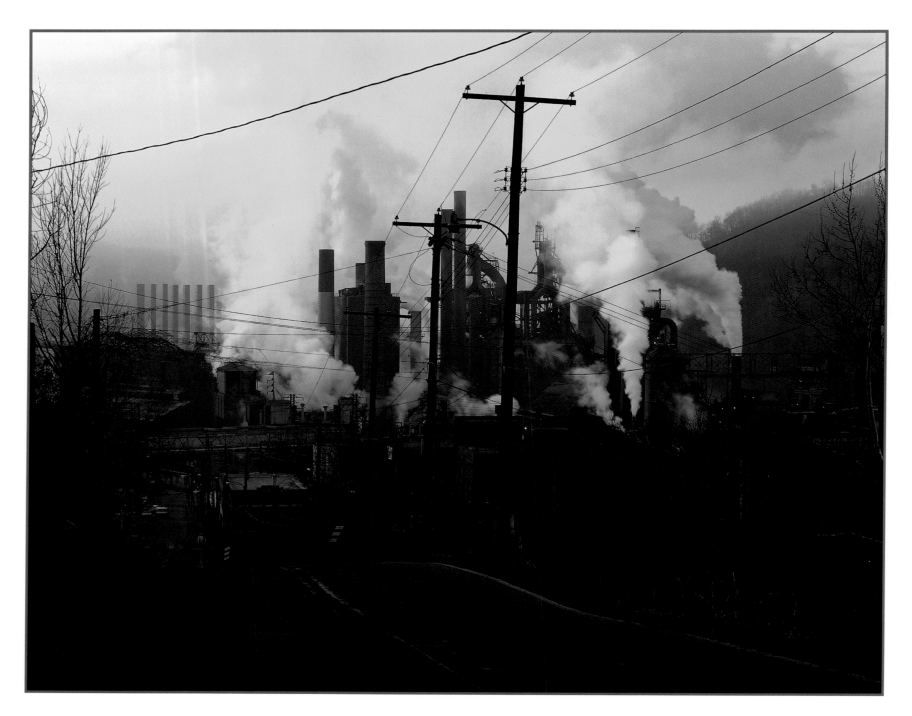

Weirton Steel at Sunrise. Weirton, West Virginia.

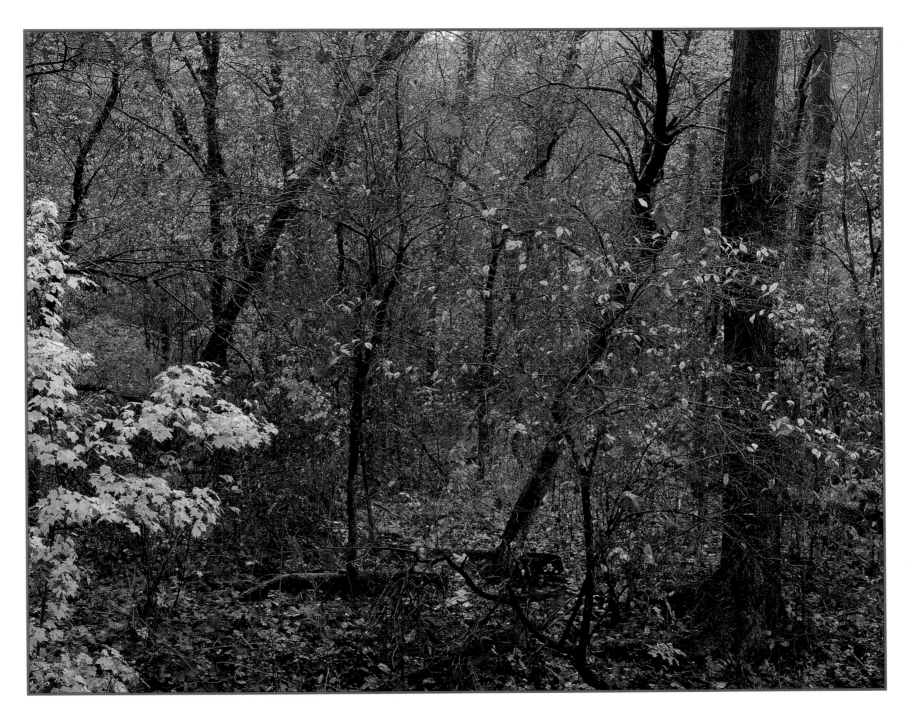

Autumn in Southern Ohio. Near Salineville, Ohio.

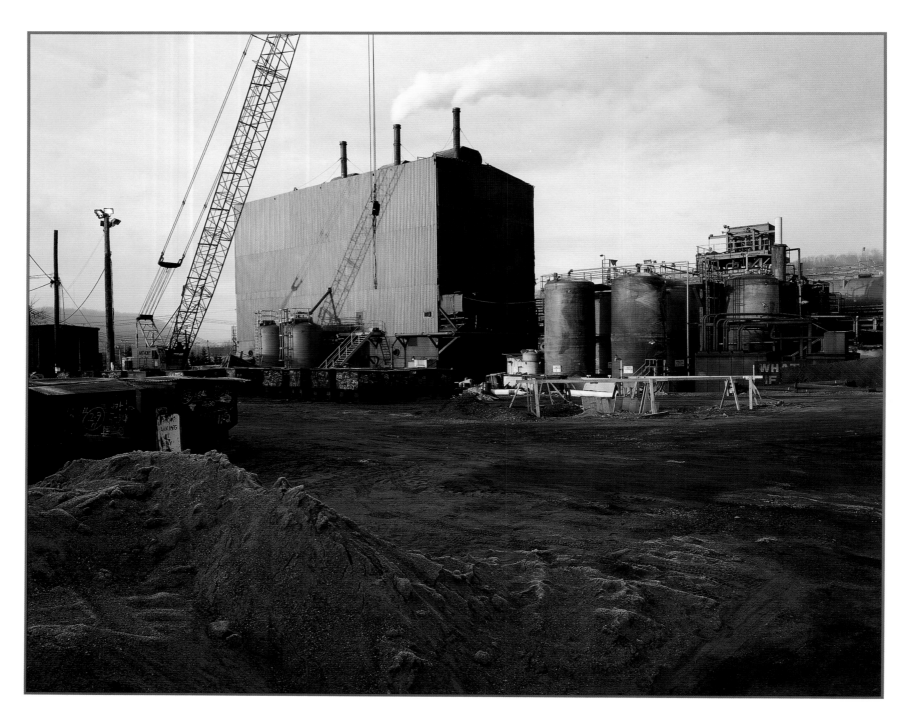

Construction, Weirton Steel. Weirton, West Virginia.

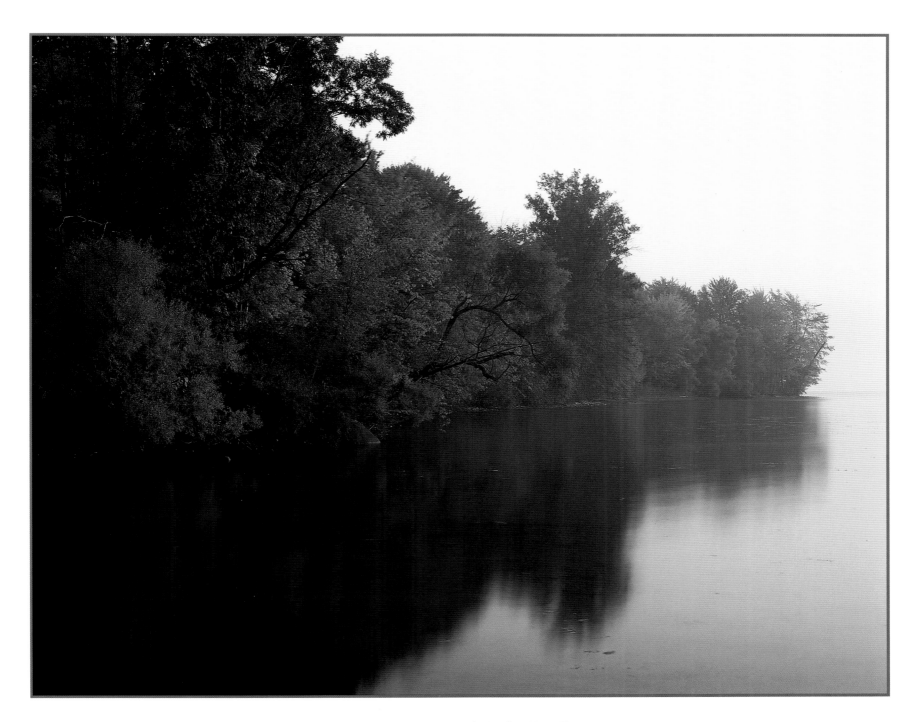

The Water's Edge. Homage to the Hudson River Painters.

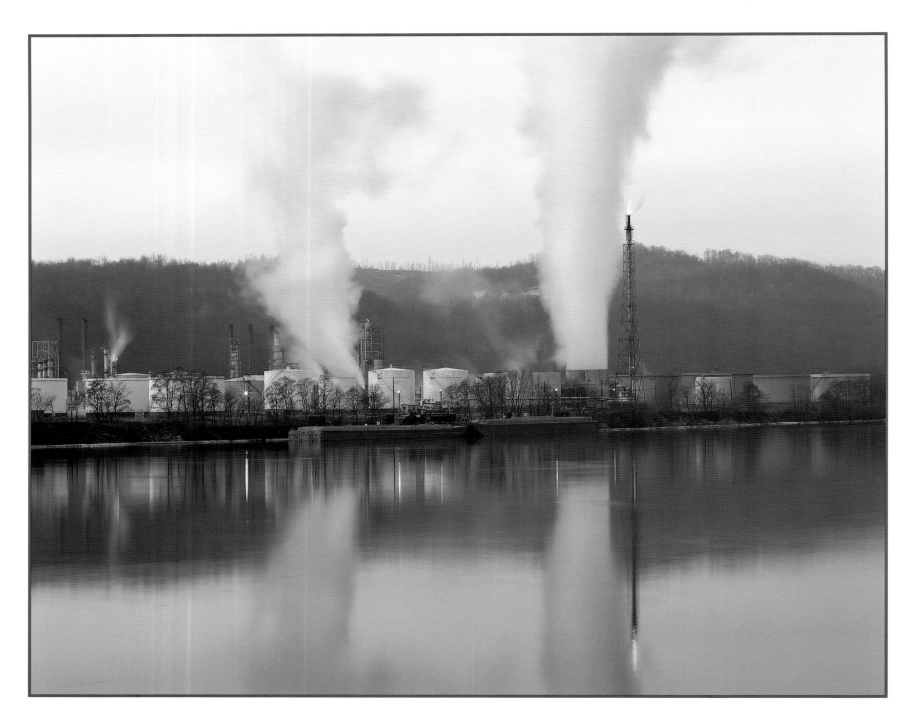

The Quaker State Oil Company. Newell, West Virginia.

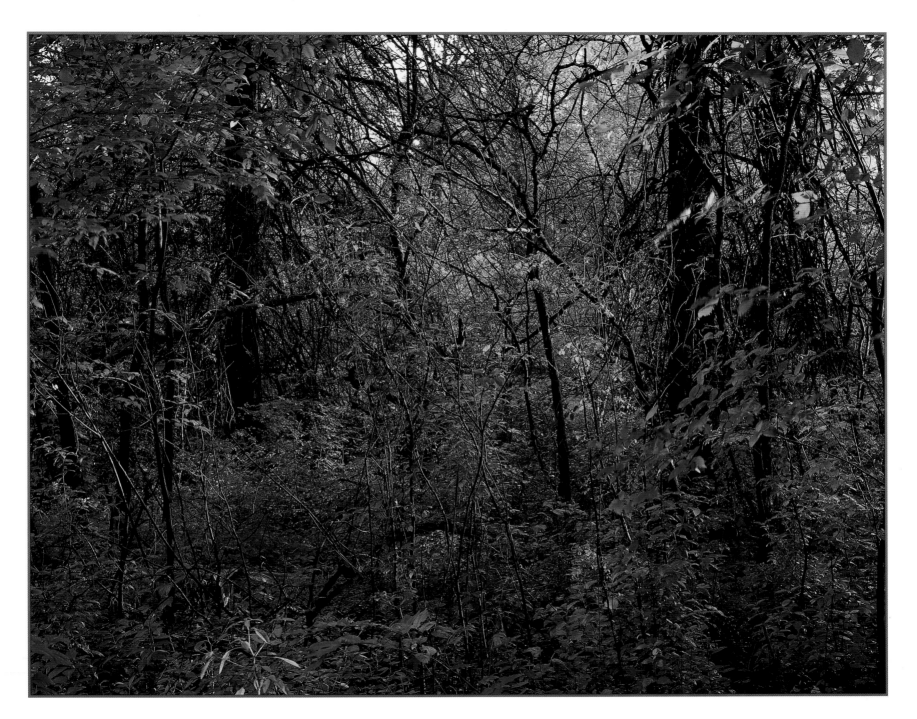

It's Just Green. Hilltop south of Hubbard, Ohio.

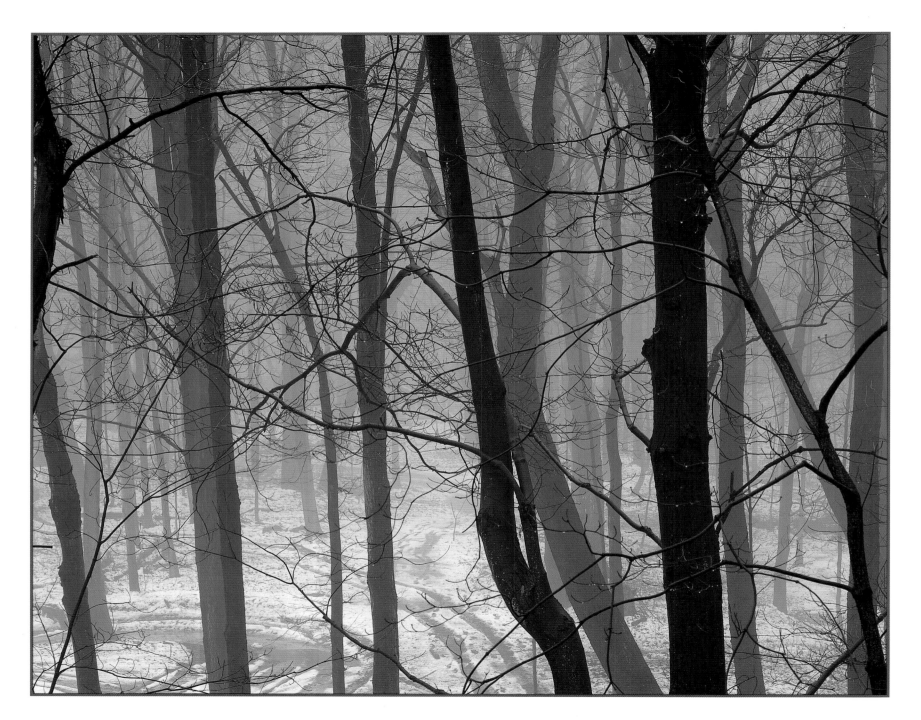

My Winter Photograph. Hubbard, Ohio.

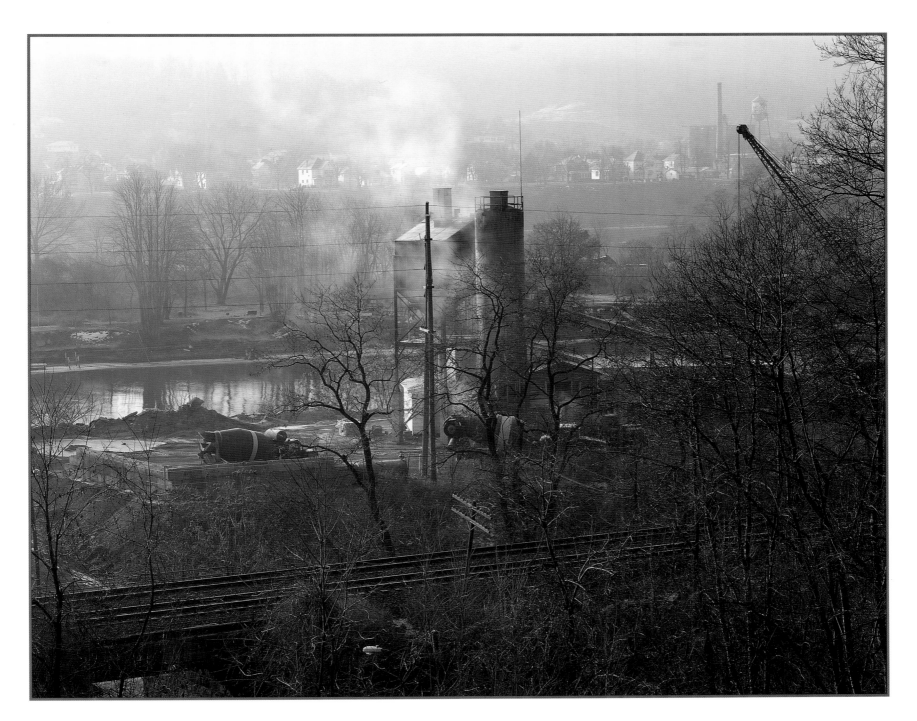

D. W. Dickey and Sons Concrete. East Liverpool, Ohio.

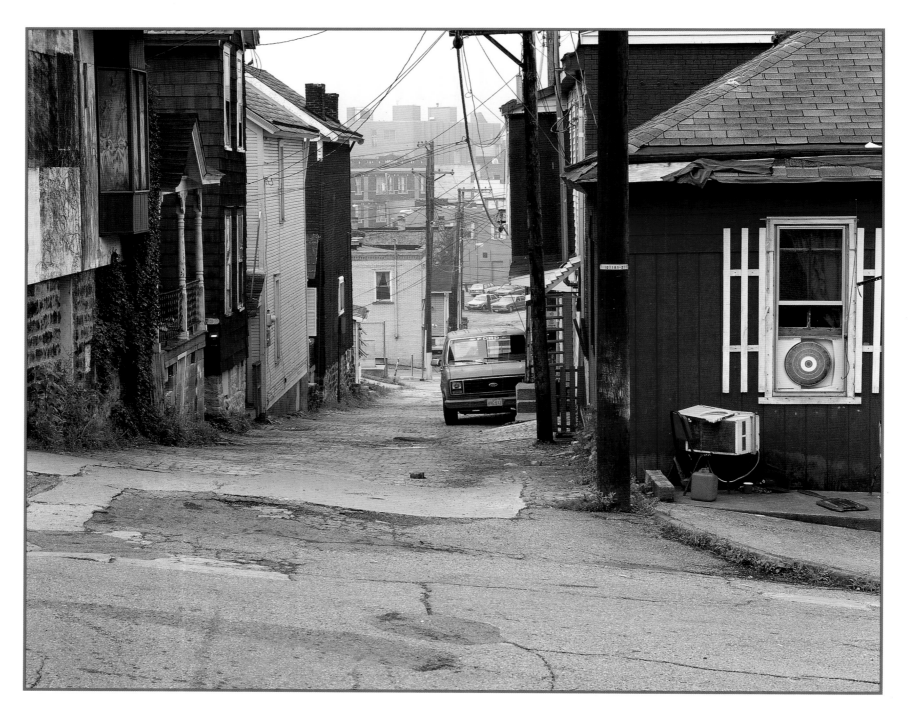

Alleyway in East Liverpool. East Liverpool, Ohio.

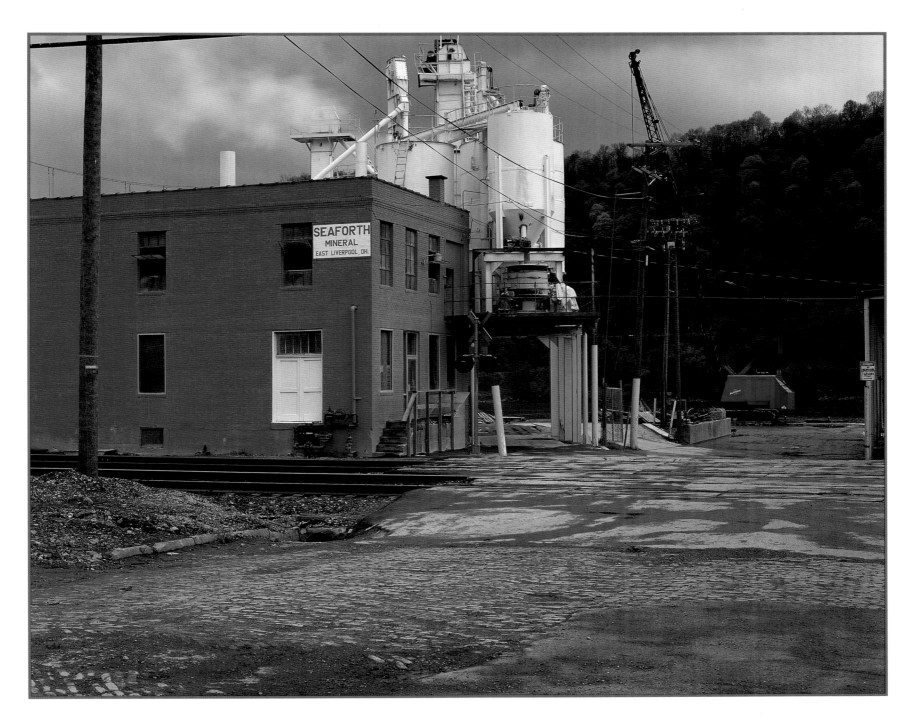

Seaforth Mineral and Ore. Along the river in East Liverpool, Ohio.

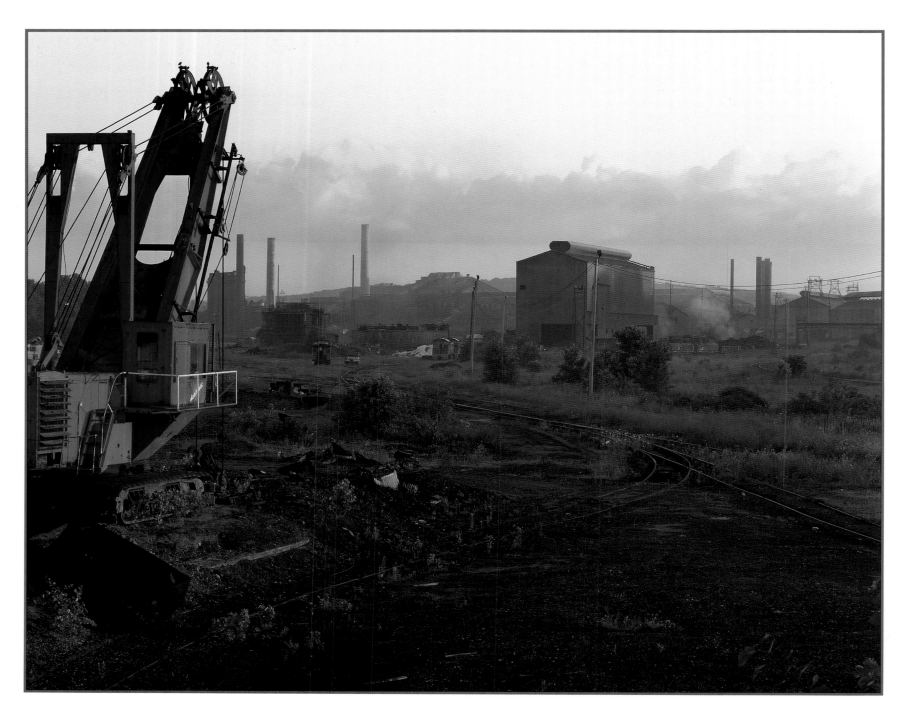

Sunrise at Sharon Steel. Sharon, Pennsylvania.

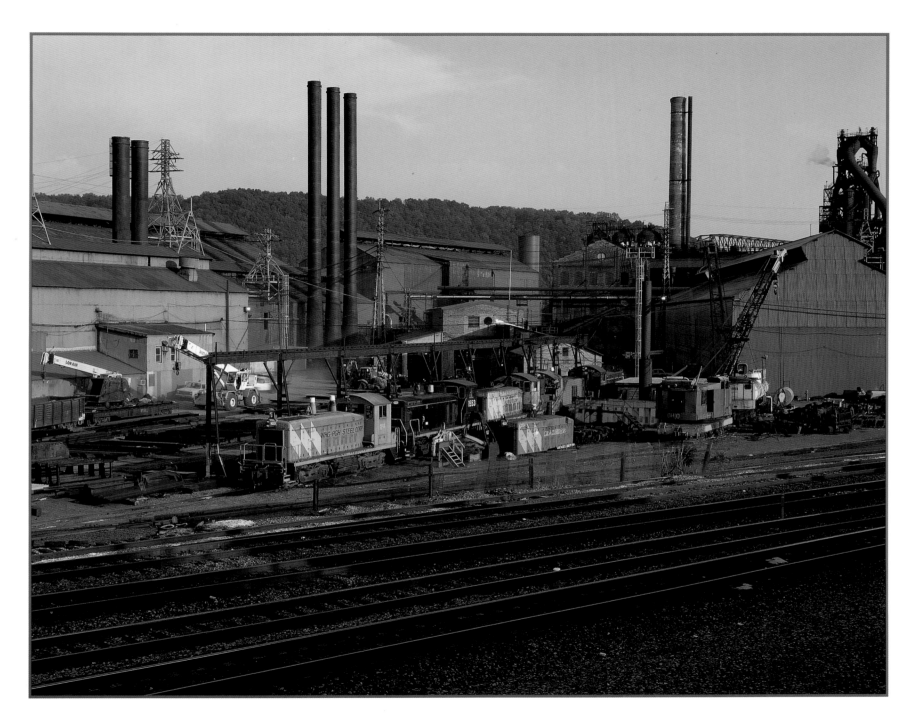

Wheeling Pittsburgh Steel. Mingo Junction, Ohio.

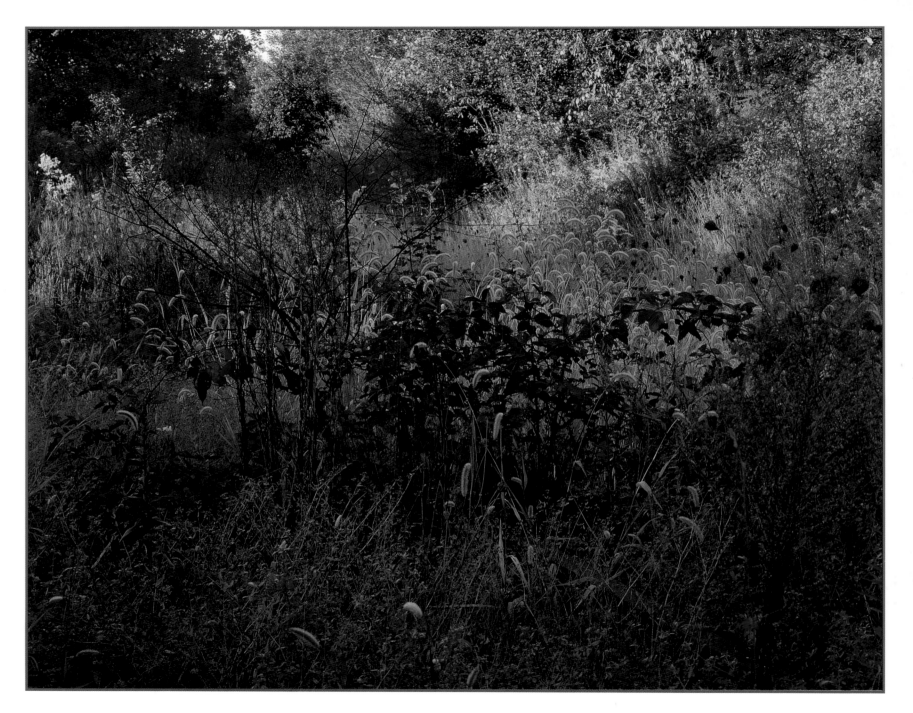

The Old Railroad Track at the North End of Hubbard. Hubbard, Ohio.

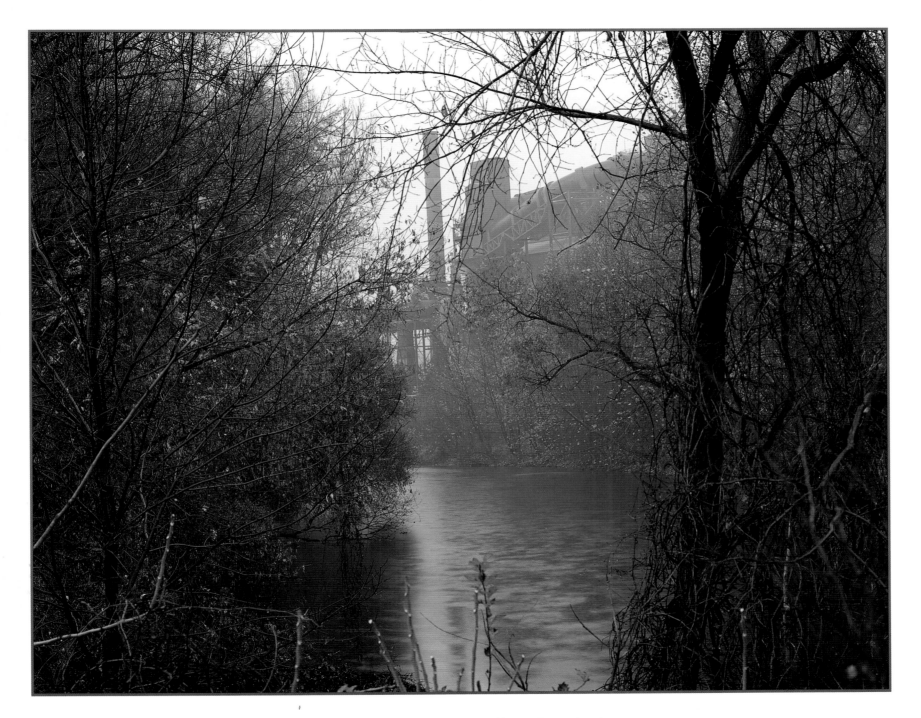

Sharon Steel from the River's Edge. Sharon, Pennsylvania.

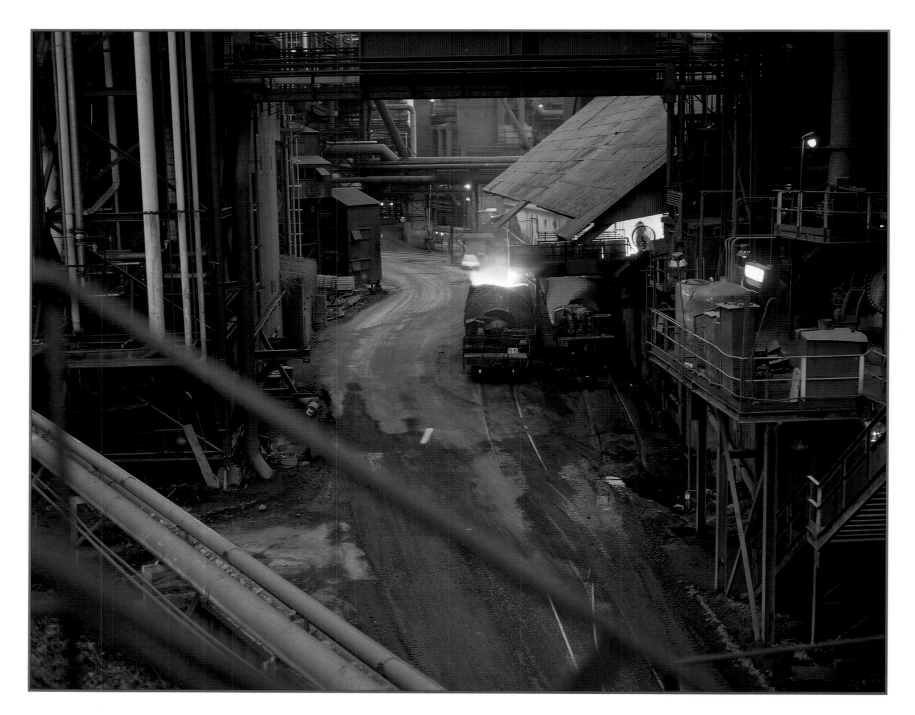

Pouring Steel in Weirton. Weirton, West Virginia.

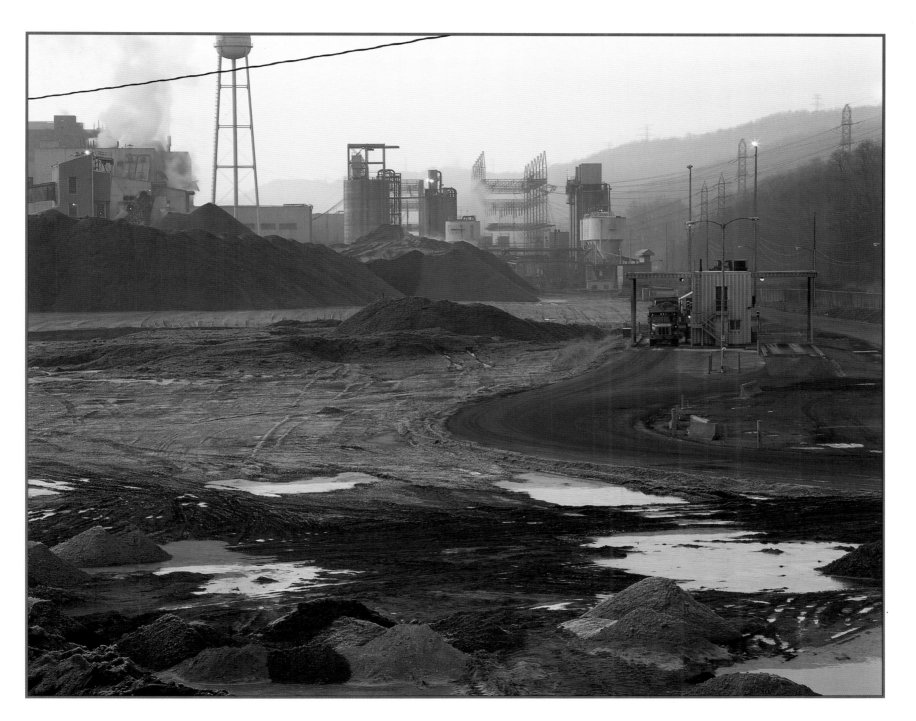

Weigh Scale at the Sammis Plant. South of East Liverpool, Ohio.

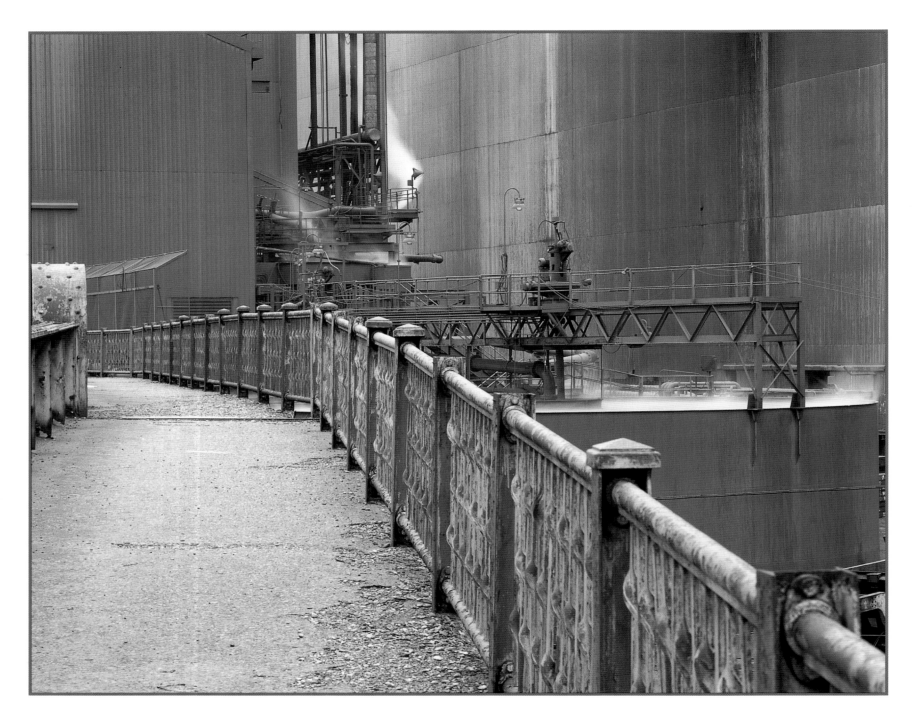

Sidewalk on Main Street. Weirton, West Virginia.

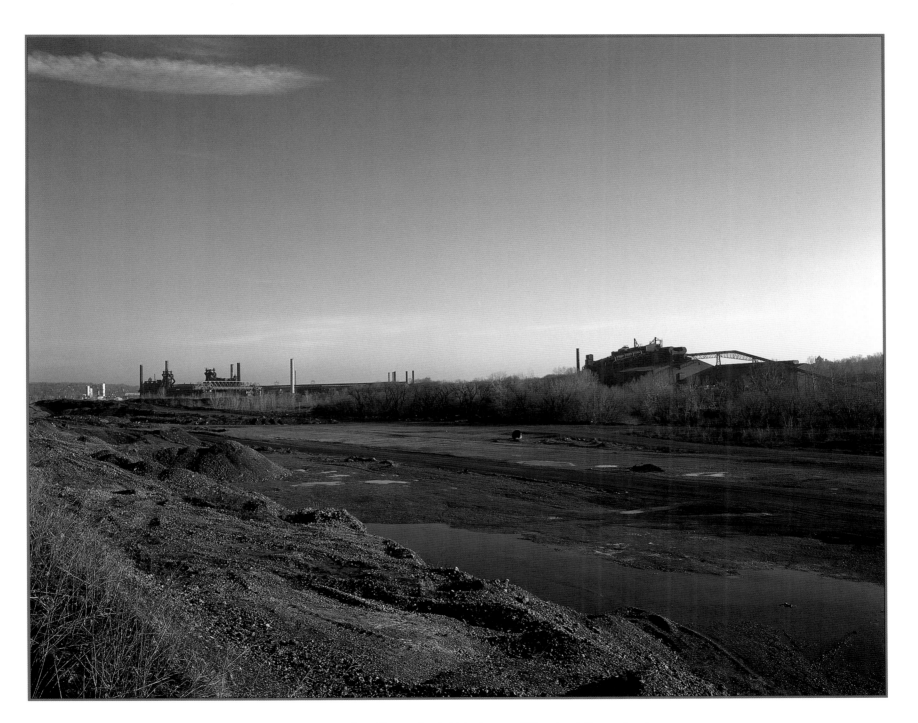

The Valley across from Sharon Steel. Ohio Avenue, Wheatland, Pennsylvania.

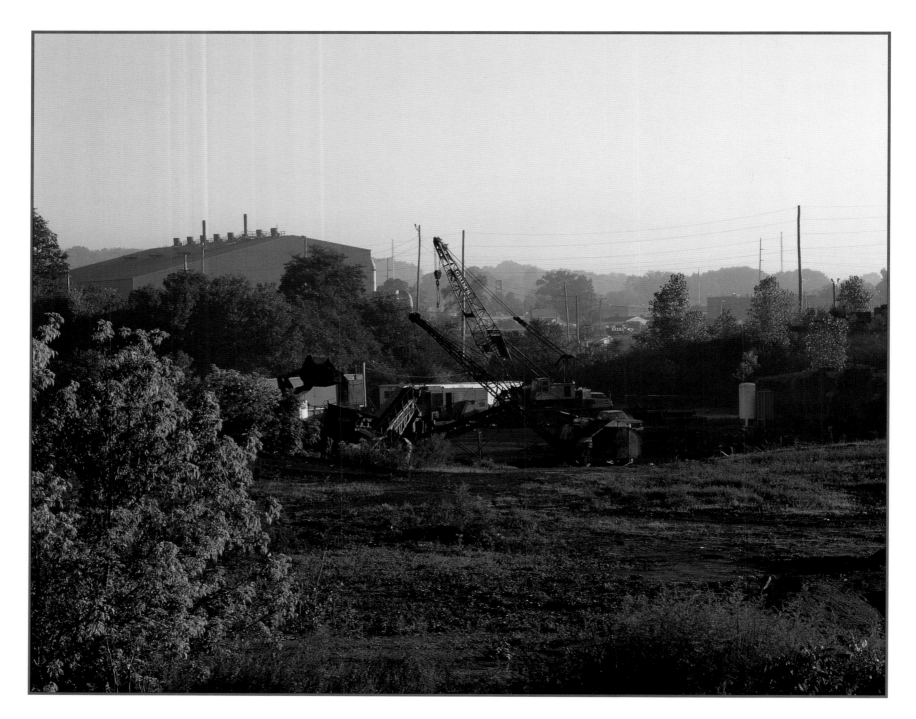

Behind the Valley Mould. Hubbard, Ohio.

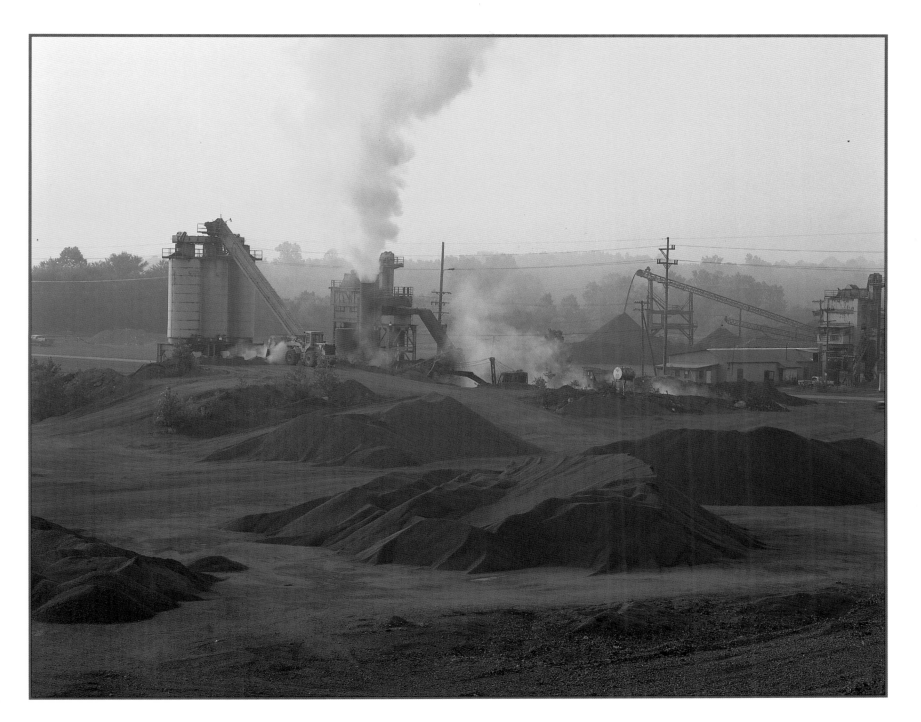

Dunbar Slag. Ohio Avenue, Wheatland, Pennsylvania.

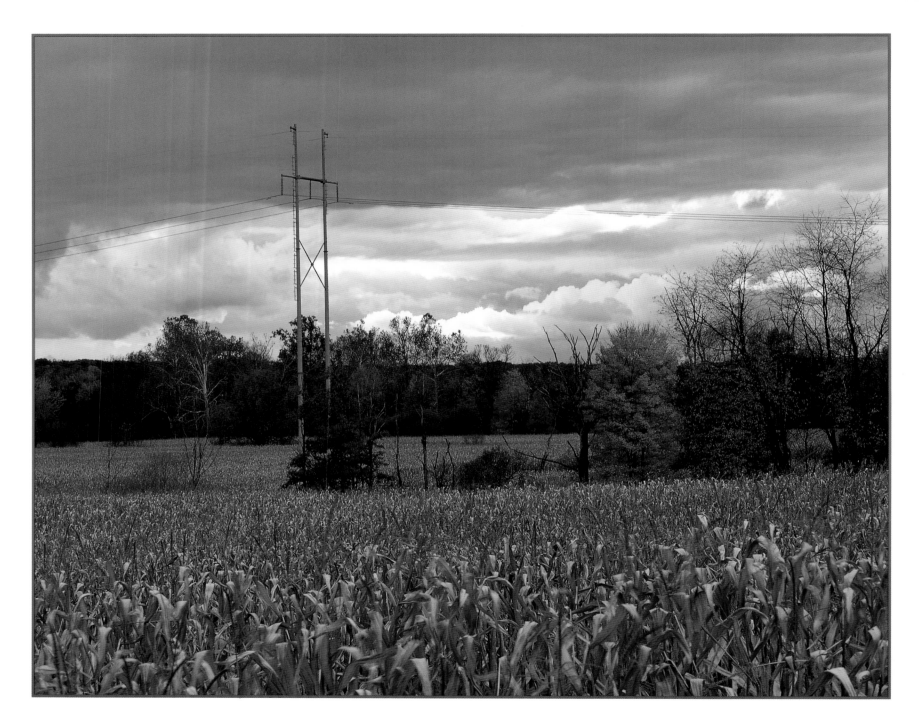

Snow Clouds in Autumn. Orangeville, Ohio.

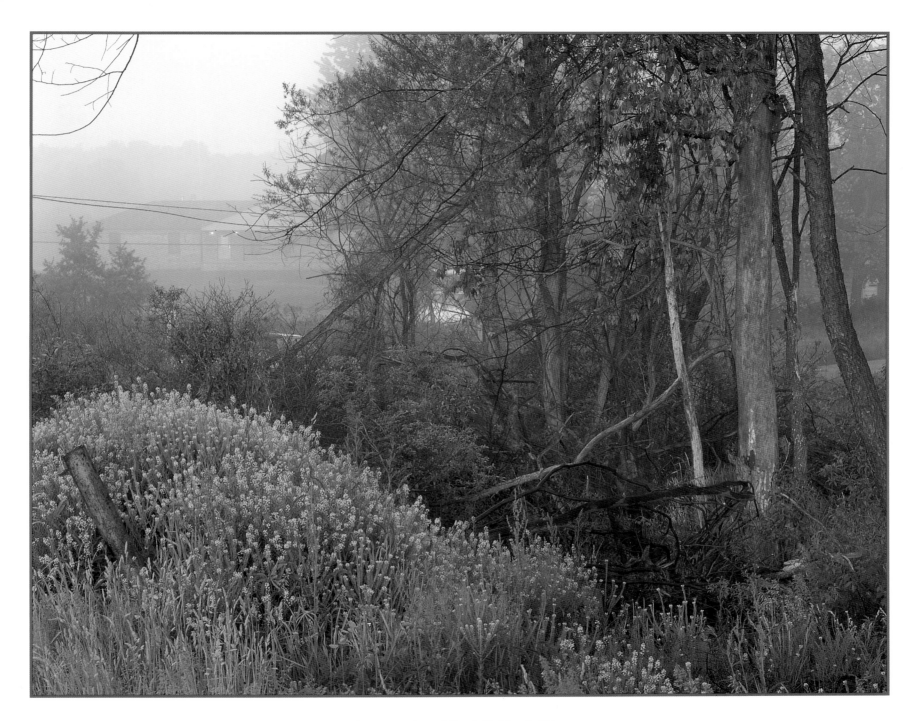

Sunrise on Pound Road. Hubbard, Ohio.

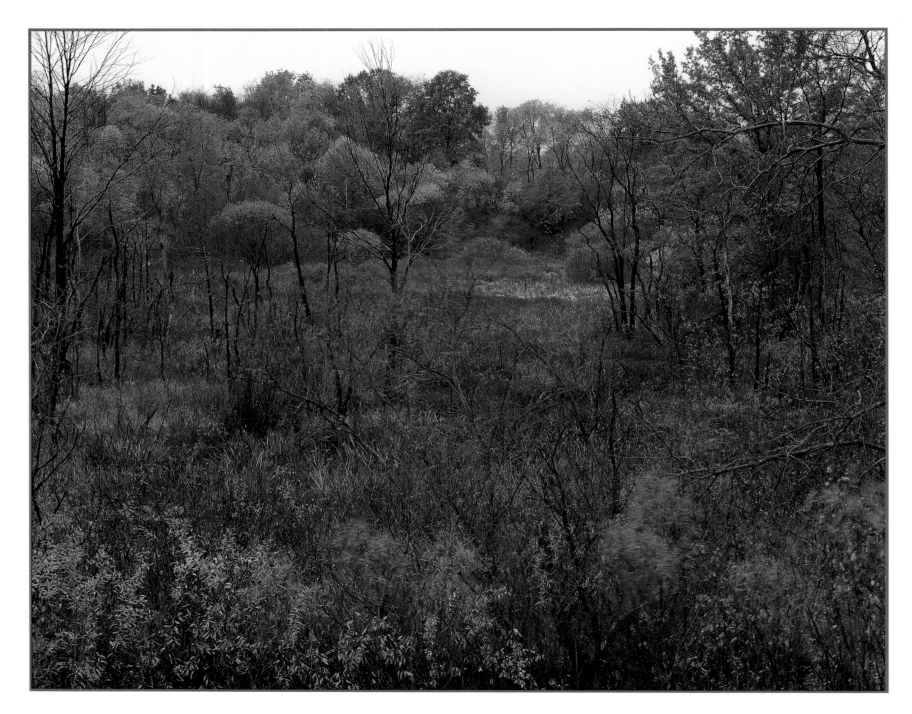

A Swamp behind Mickey D's. Interstate 80, Hubbard, Ohio.

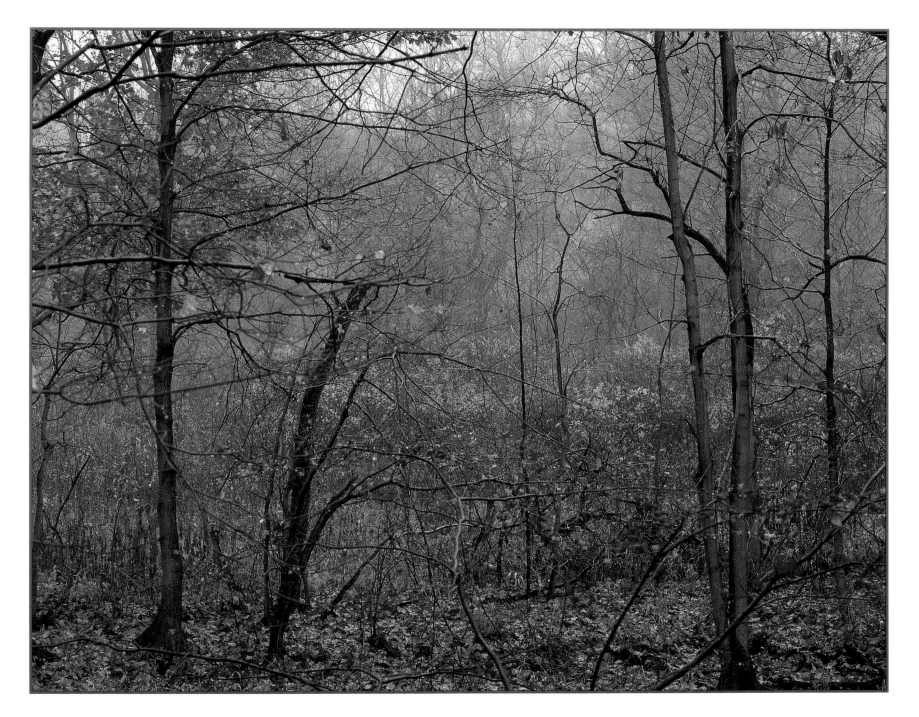

Across the River. Fox North Road, Hubbard, Ohio.

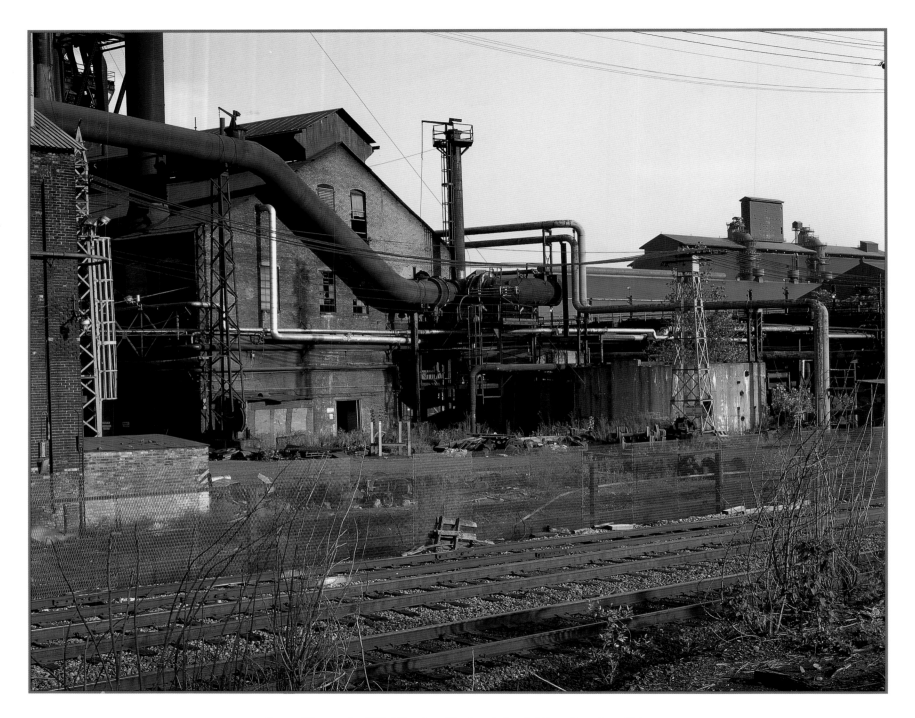

Steam Pipes at the Mill. Wheeling Pittsburgh Steel, Mingo Junction, Ohio.

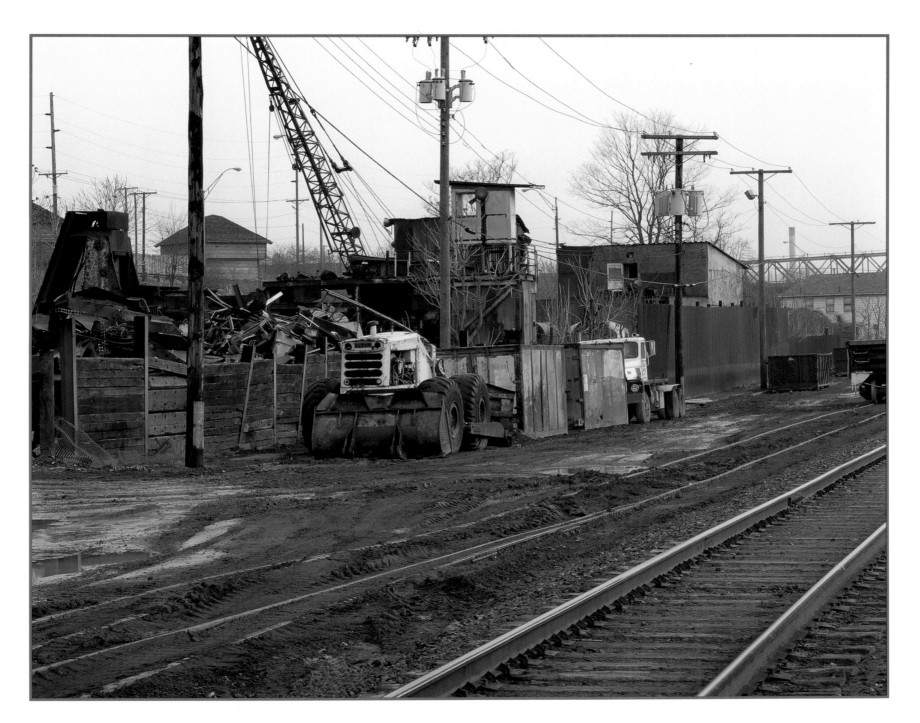

Scrapyard in Mingo Junction. Mingo Junction, Ohio.

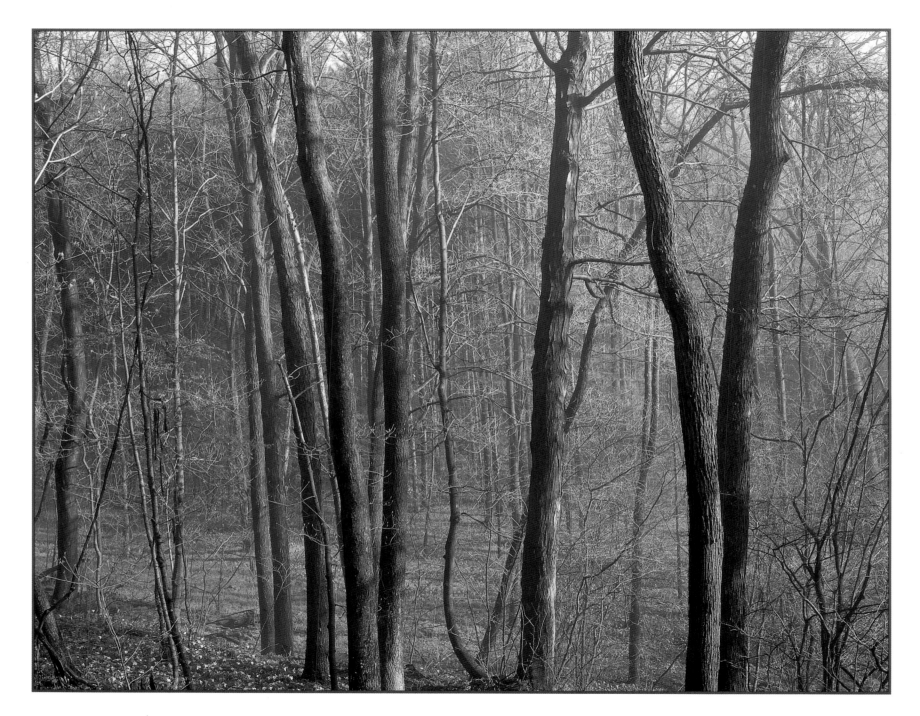

Trilliums in Beaver Creek. Beaver Creek State Park, Ohio.

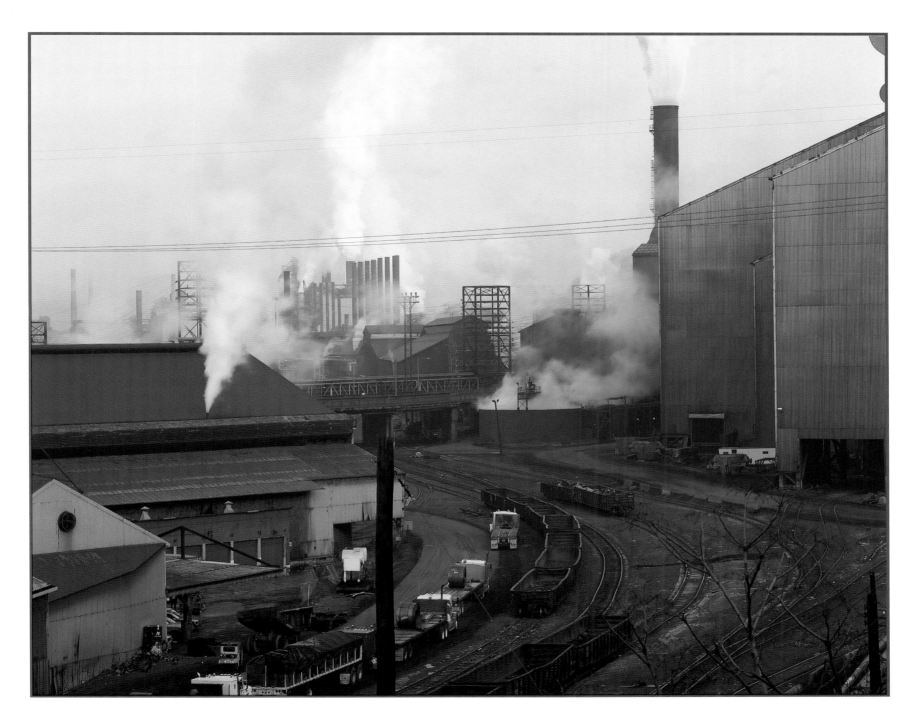

A Bird's-Eye View. Weirton Steel, Weirton, West Virginia.

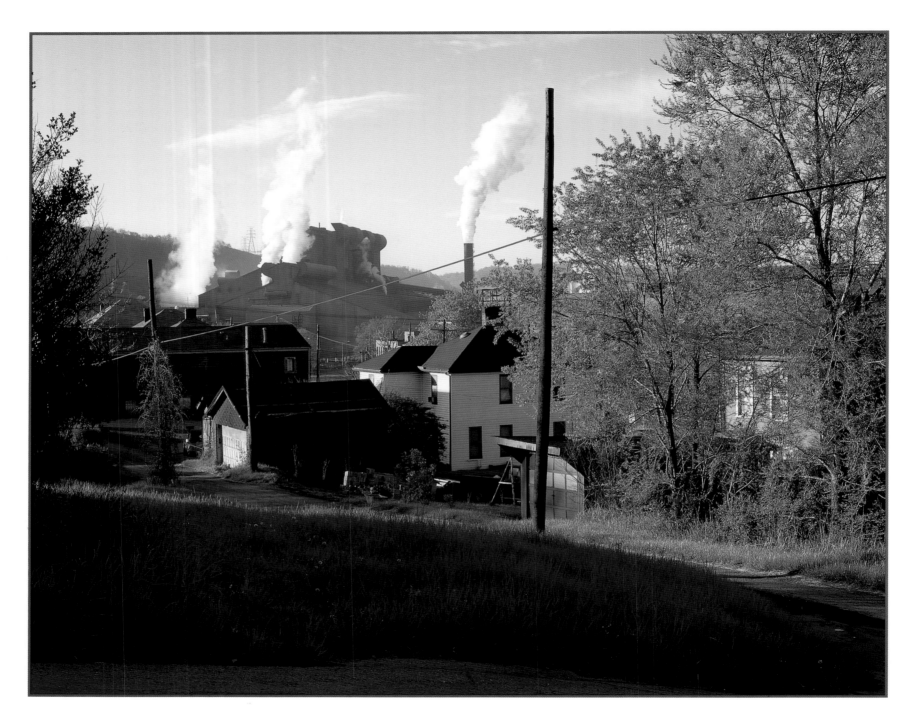

A Backyard in Weirton. Weirton, West Virginia.

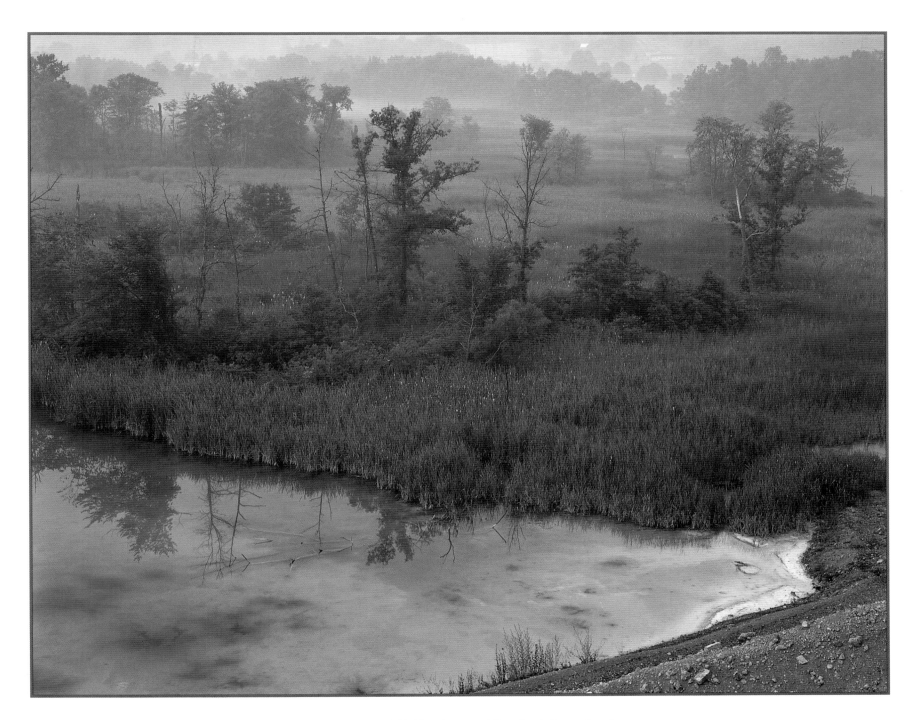

Runoff from Rainfall. Ohio Avenue, Wheatland, Pennsylvania.

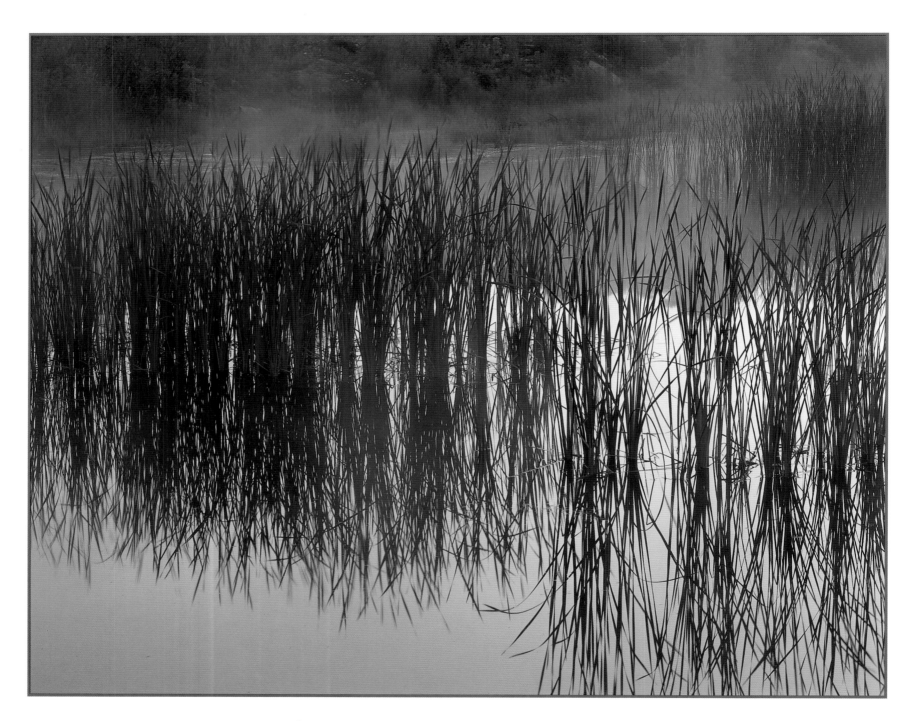

Grasses in a Pond. Homage to Harry Callahan. Leetonia, Ohio.

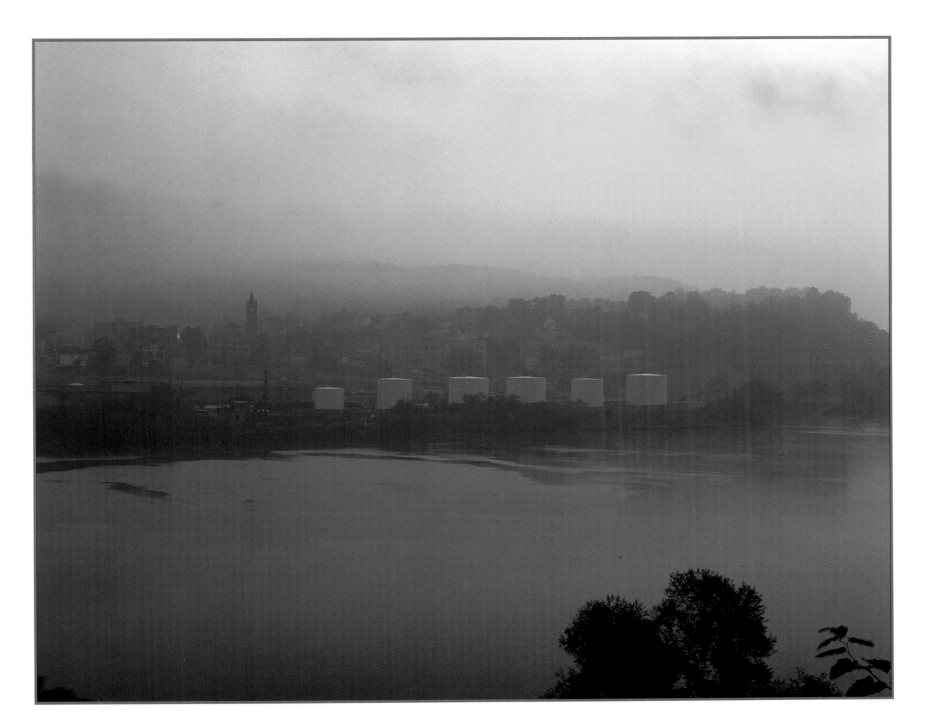

East Liverpool at Dawn. East Liverpool, Ohio.

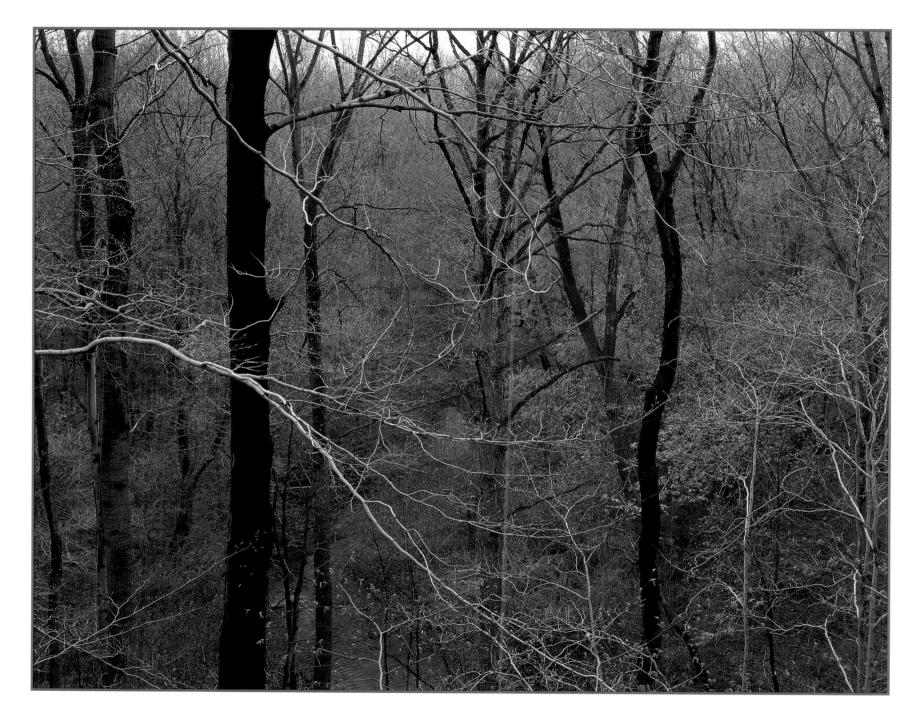

Harding Park. Hubbard, Ohio.

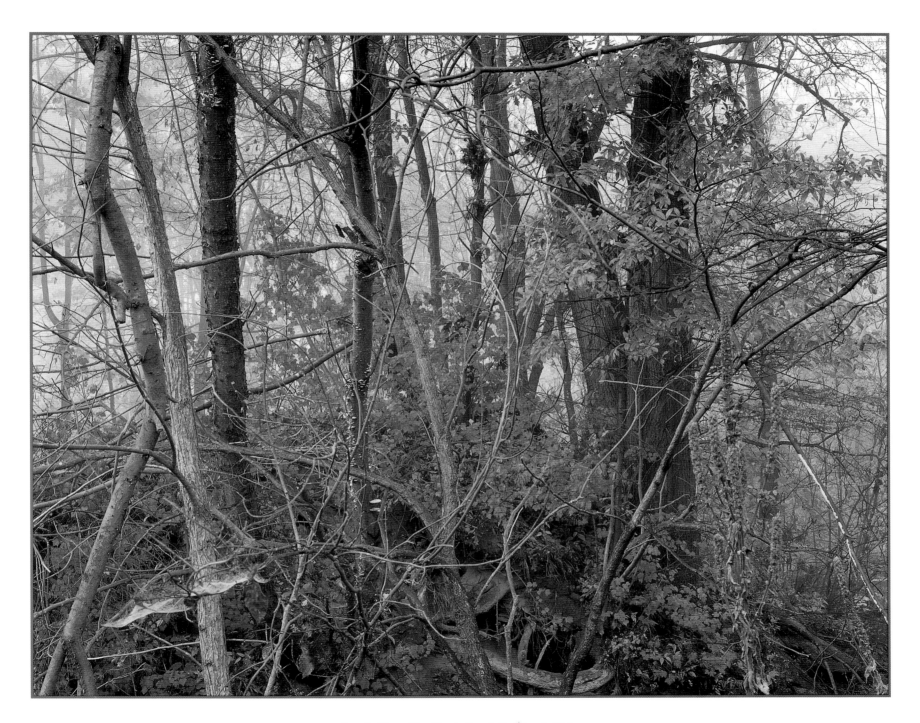

Less Is More. Fox North Road, Hubbard, Ohio.

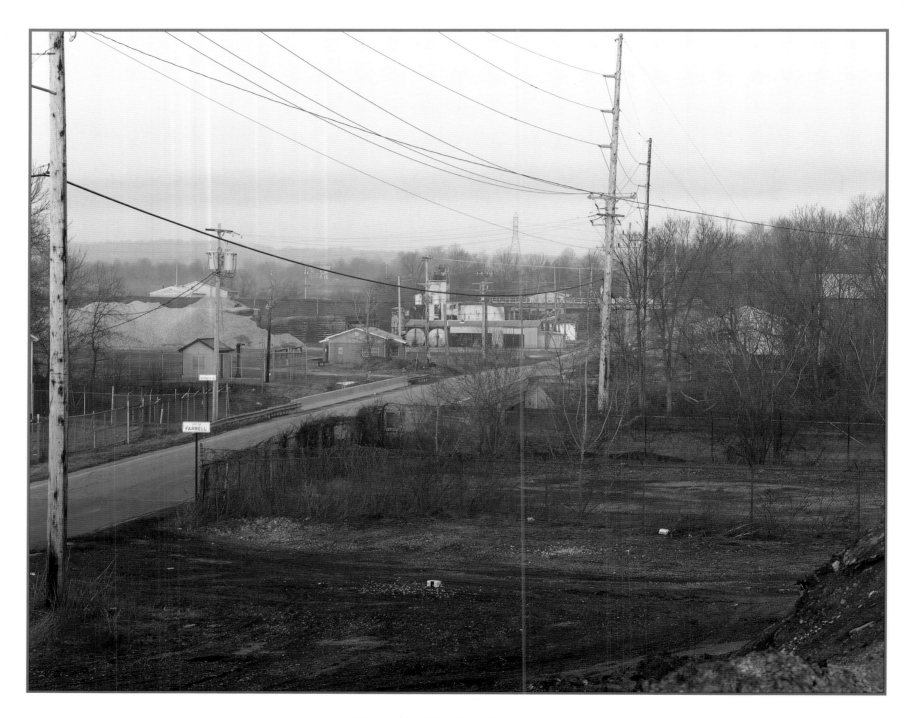

Ohio Avenue. Wheatland, Pennsylvania.

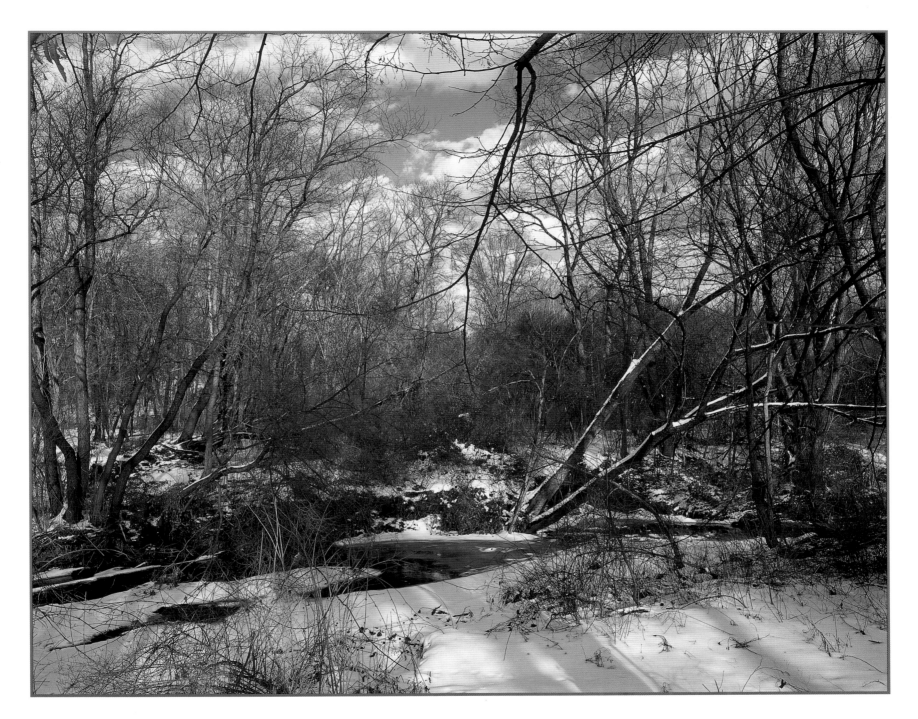

Winter on Mackey Street. Hubbard, Ohio.

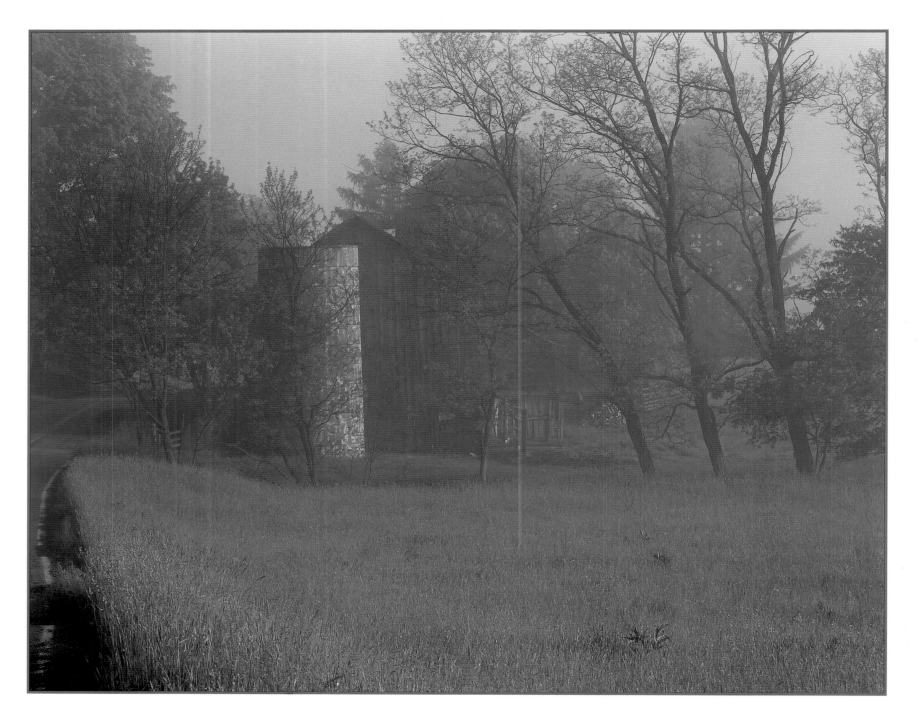

Schotten Road. Hubbard, Ohio.

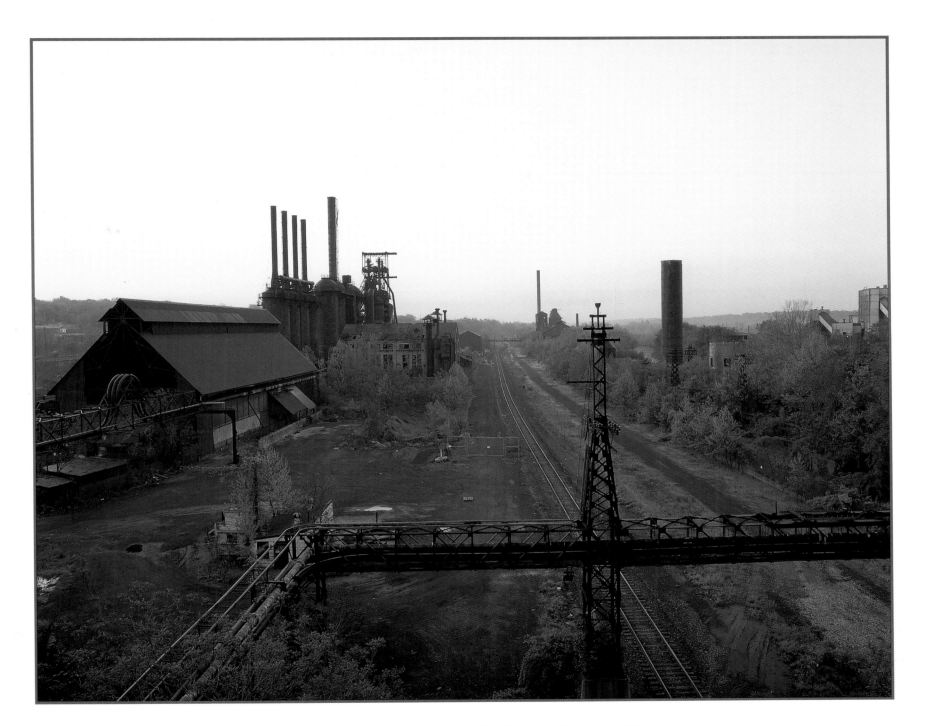

Jenny, I'm Sinkin' Down. The Jeanette Blast Furnace, Youngstown, Ohio.

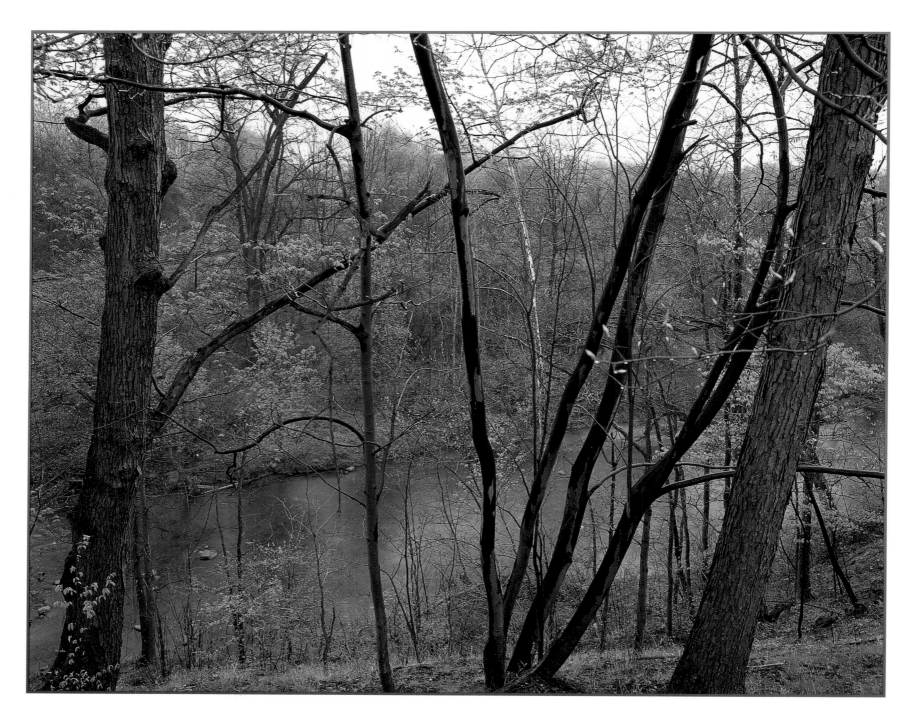

Spring at the Second Bridge. Homage to George Toth.

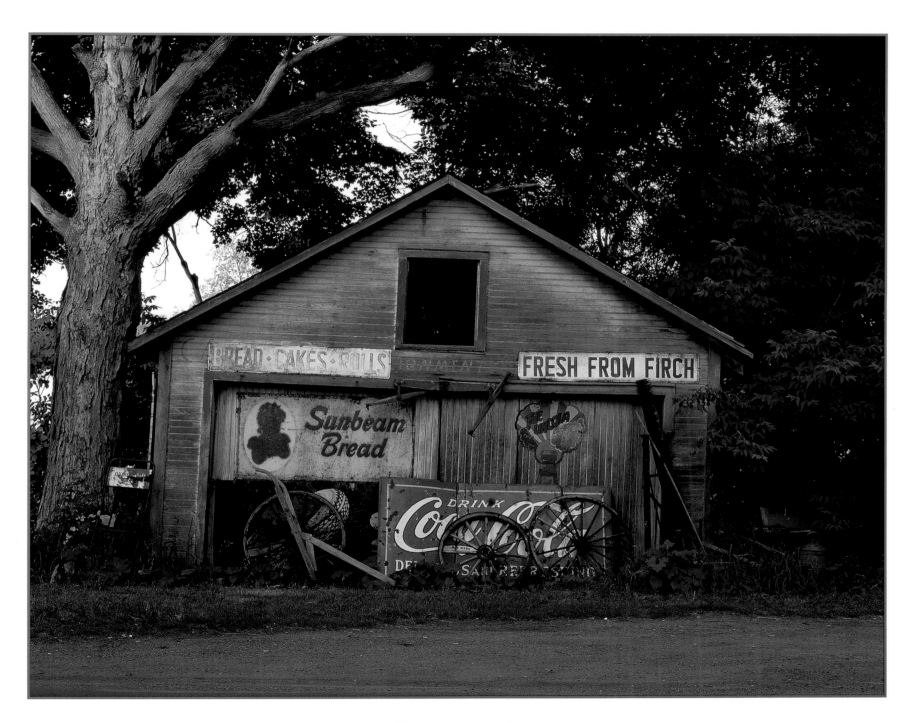

An Old Barn in Andover, Ohio.

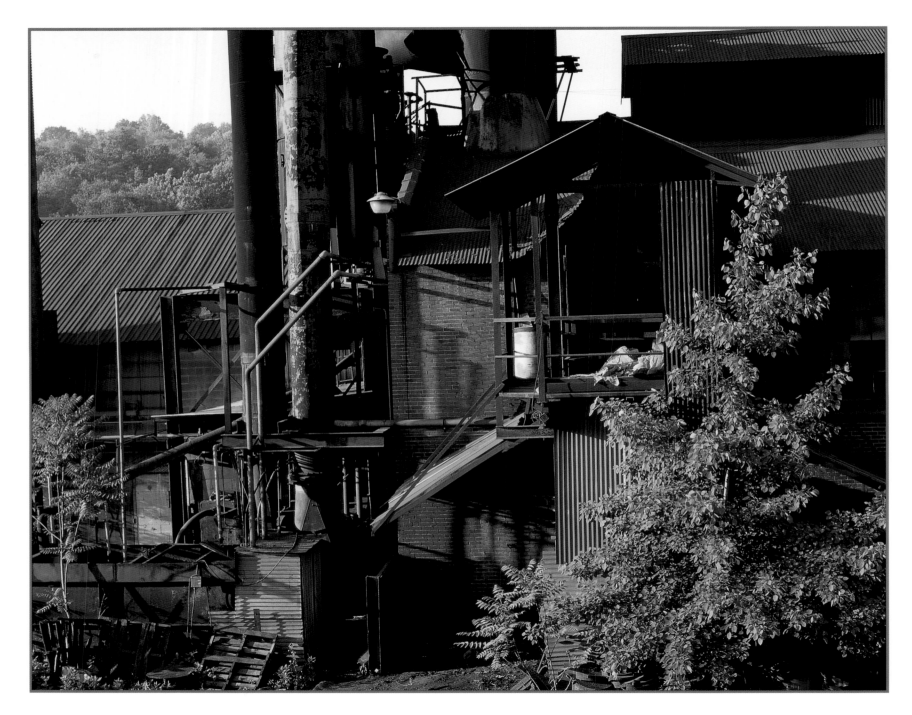

The Old Foundry. Newcastle, Pennsylvania.

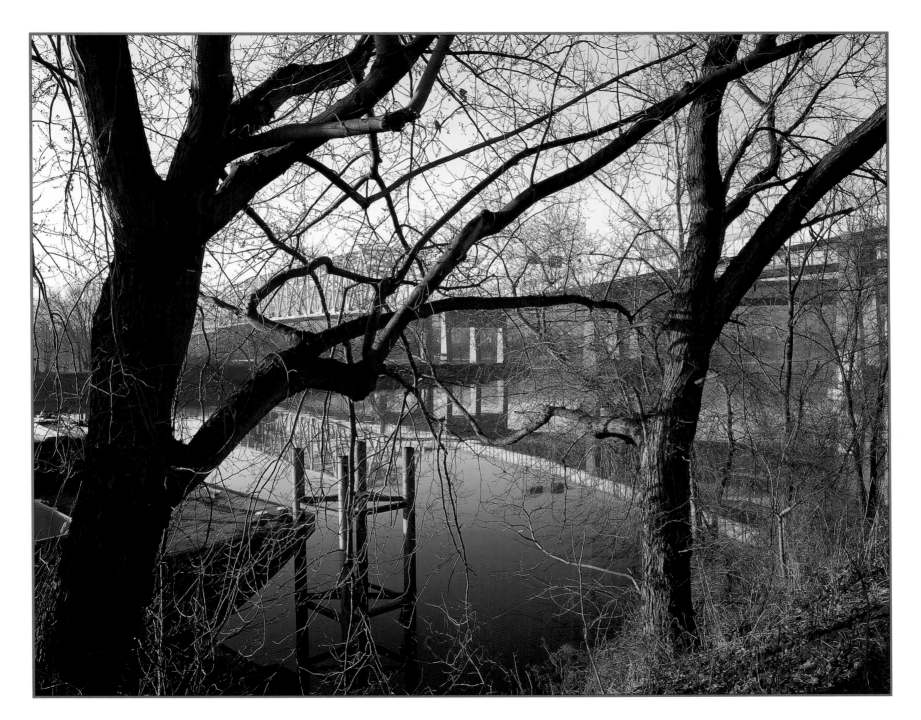

Sunrise on the Ohio. Ohio River at East Liverpool, Ohio.

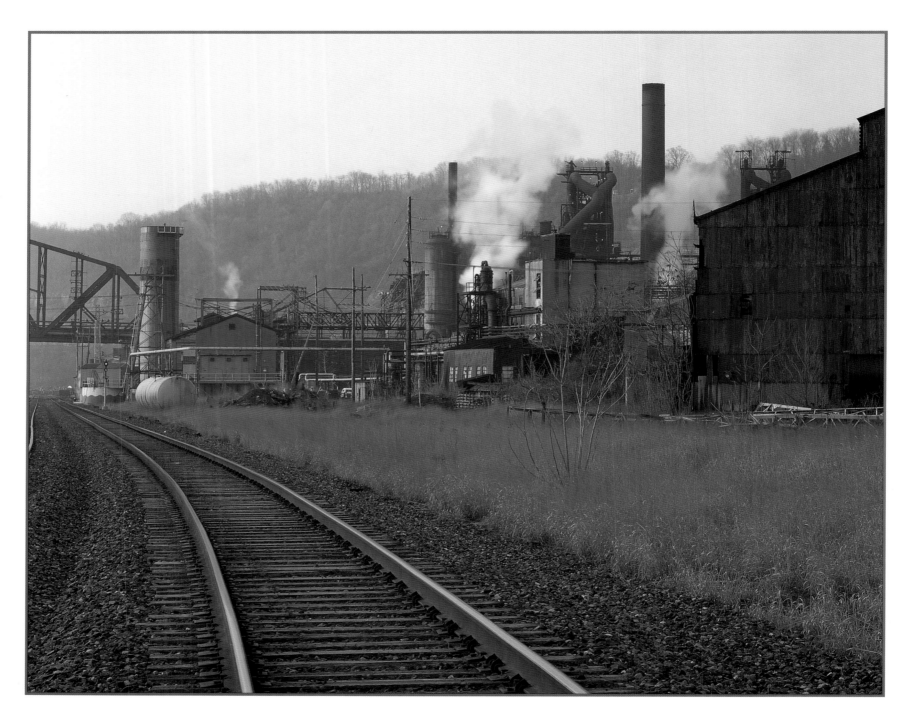

Railroad Track at the Mill. Wheeling Pittsburgh Steel, Mingo Junction, Ohio.

Images of the Rust Belt

was designed and composed

by Will Underwood

at The Kent State University Press

in 11.5/16.5 Bodoni Book with Berthold Bodoni Light figures

on an Apple Power Macintosh system using Adobe PageMaker;

printed in four color process on 157 gsm Japanese enamel gloss stock,

Smyth sewn and bound over binder's boards in Brillianta cloth,

and wrapped with dust jackets printed in four color process

by Everbest Printing Co. Ltd. of Hong Kong;

and published by

The Kent State University Press

KENT, OHIO 44242 USA

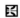